Painting
PASTEL
LANDSCAPES

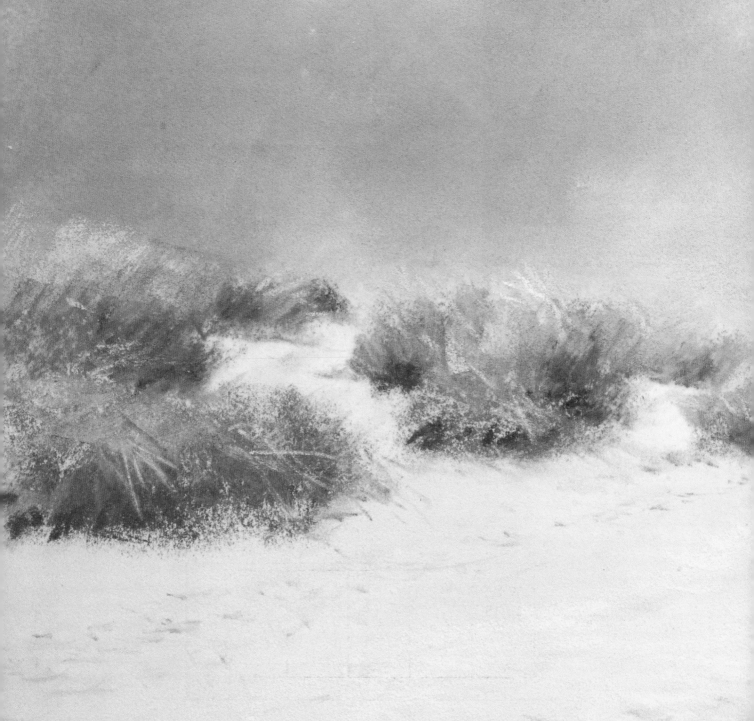

Dedication

To all my art teachers at school, Southport College of Art and
Harrow College of Art, who taught so well this most fascinating
form of creativity; who encouraged me to be myself and do
what I enjoy doing. This is also dedicated to
my parents, who let me.

Painting
PASTEL
LANDSCAPES

Jeremy Ford

First published in 2015

Search Press Limited
Wellwood, North Farm Road,
Tunbridge Wells, Kent TN2 3DR

Text copyright © Jeremy Ford 2015

Photographs by Paul Bricknell, Search Press Studios

Photographs and design copyright © Search Press Ltd.
2015

ISBN: 978-1-78221-116-7

The Publishers and author can accept no responsibility for
any consequences arising from the information, advice or
instructions given in this publication.

Suppliers

If you have difficulty in obtaining any of the materials
and equipment mentioned in this book, please visit the
Search Press website for details of suppliers:
www.searchpress.com

Publishers' note

All the step-by-step photographs in this book feature
the author, Jeremy Ford. No models have been used.

Acknowledgements

I'd like to thank my family for putting up with
me during the chaotic process of writing this
book, to Elizabeth Ford for typing and helping
me make it coherent, to John Wood for his
photograph of the River Darwen which I used
as reference for my pastel painting, and
particularly my editor Becky Shackleton, for
all her patience and enthusiasm, which has
enabled this book to be put together so well.

Printed in Malaysia

Contents

Introduction

I am fortunate to have been an artist all my life. I have studied art for as long as I can remember and it is a constant pleasure to learn and discover and then pass on this knowledge to others. You never know everything – there is always more! It's been my intention to write a book about chalk pastels for a while now, as there is something very special about this medium, and yet it often seems to be overlooked. As soon as I started using pastels, I loved the directness of touching them on to the paper surface, smoothing, blending and working them, and watching the painting develop. I like the way that there's no time pressure compared with paint; you can stop and start whenever you want and there's no worrying about wetness or dryness. Chalk pastels are often considered to be a messy medium, but I don't find that to be true, and this book will show you that they needn't be.

The landscape is a fantastic subject for chalk pastels and it is an inexhaustible subject for every artist. It continually changes with the seasons, and the light changes with the weather and the time of day. I never tire of trying to capture a moment in time of somewhere that appeals to me, or re-creating special scenes from treasured photographs. In fact, I will often paint the same subject over and over again, and each time it's different.

Pastels are a most wonderful means of expression, and I hope that this book will help to increase their popularity. I hope this book fires your enthusiasm and fills you with ideas for creating your own chalk pastel masterpieces. Let's spread the word!

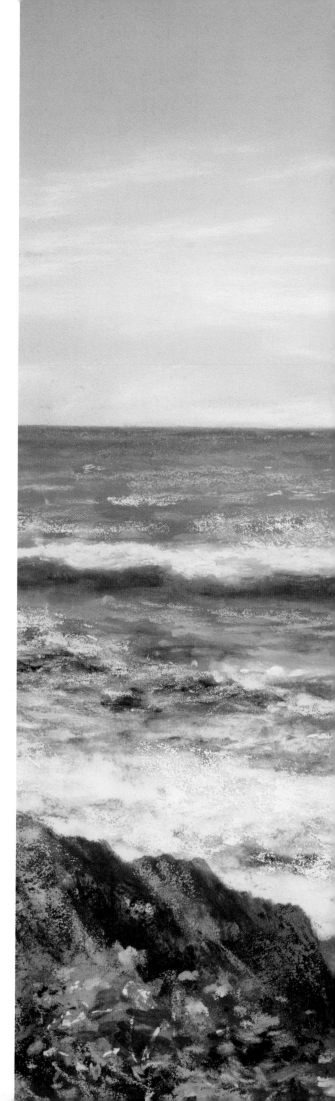

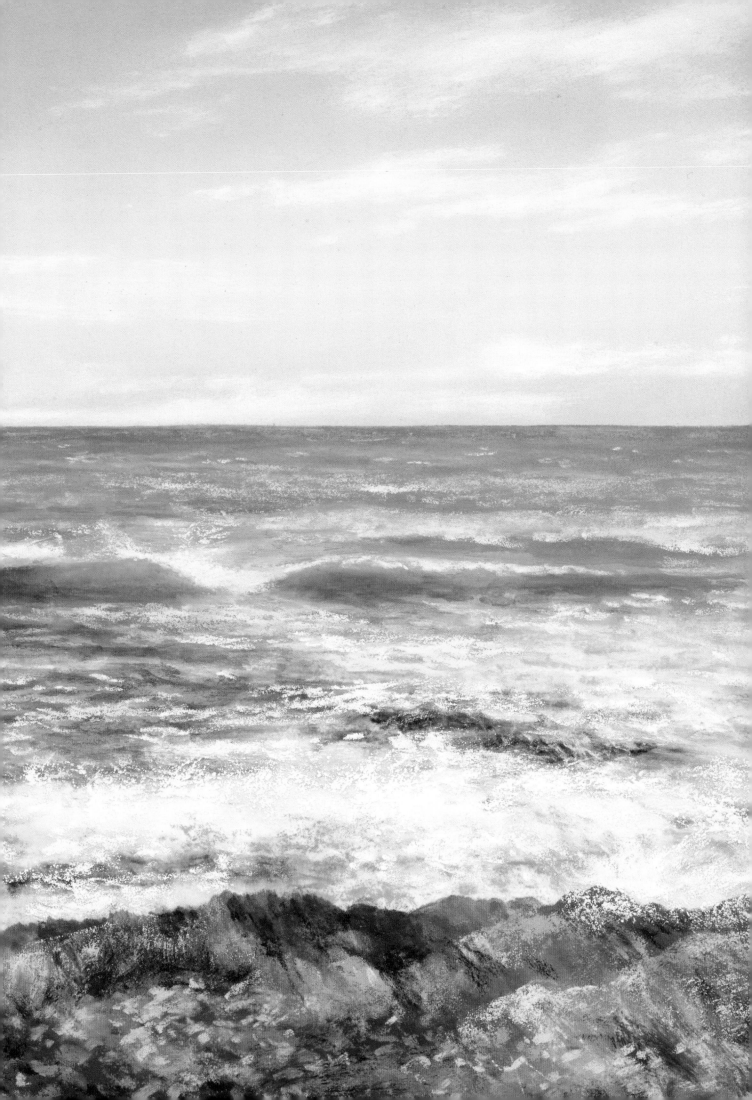

Materials

Chalk pastels

When applied to paper, chalk pastels, or pastel chalks, can be blended and manipulated to create beautifully soft effects, although you can also use their edges to create bold, sharp lines. They are sticks of powdered pigment combined with a binder. The composition of the pastel will affect its characteristics – there can be a wide range of consistency of pastel between different manufacturers: some soft, some much harder. I have many different makes of pastels that I have accumulated over the years and they vary greatly in handling. You may need to experiment with a few different makes, to find the type you like to work with.

Pastel chalks come in a mouthwatering array of colours. Many can be bought as individual colours or you can buy them in sets. You may see some sets termed 'Landscape', 'Floral' or 'Portrait', for example, and these will contain a limited number of selected pastels that are appropriate for use on that particular subject.

Oil pastels

Although this book has been written for use with chalk pastels, you could use oil pastels instead if you prefer. Oil pastels, as the name suggests, are oily or greasy in nature and may be blended with oil or turpentine to soften them.

Pastel pencils

If you are working in a small area or on a small scale, pastel pencils are very useful for precise, detailed work. They generally tend to be harder than sticks of pastel, creating much crisper lines, but there's a lot of variation between pastels of all kinds: some are very soft and others much harder. I generally only use pastel pencils for fine detail, and as much of my work isn't particularly detailed I tend to keep only a limited range of colours.

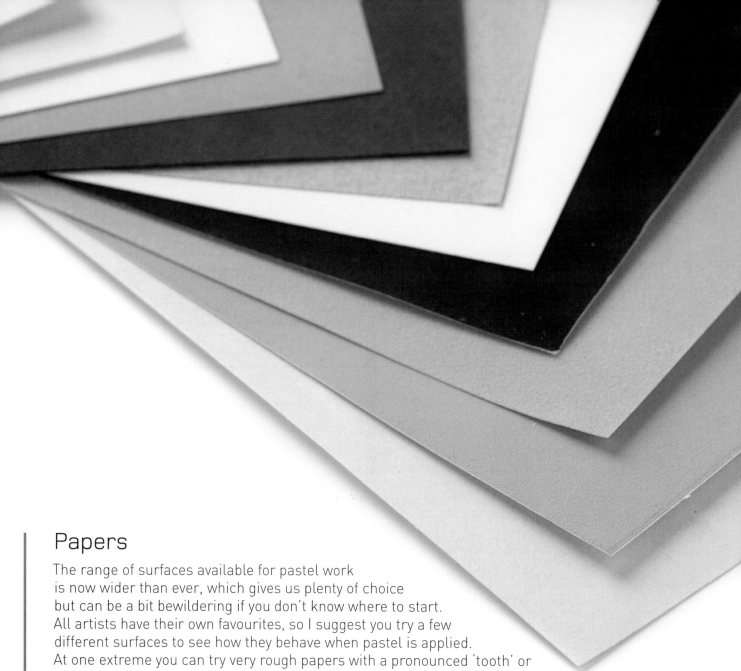

Papers

The range of surfaces available for pastel work
is now wider than ever, which gives us plenty of choice
but can be a bit bewildering if you don't know where to start.
All artists have their own favourites, so I suggest you try a few
different surfaces to see how they behave when pastel is applied.
At one extreme you can try very rough papers with a pronounced 'tooth' or
texture. Some of these resemble sandpaper to the touch and consequently
hold pastel really well. However, compared to smoother papers they can
create more dust when the pastel is applied, and blending colours by
rubbing with your fingers can be more challenging. On the other hand, a
thinner paper may not hold much pastel, and may also crease more easily.

Trial packs containing a variety of papers can be a good and
inexpensive way to discover which you prefer. Experiment with your
pastels, applying them lightly and heavily, creating fine lines and broad
strokes, and try blending them with your fingers to see what effects you
can achieve on each surface.

My own preference is usually Pastelmat, which is a 360gsm (170lb)
smooth, robust, thick paper, specially developed for pastel work. The
matt side is the working side; if you accidentally use the other side,
which is shiny, you'll soon realise as it hardly takes the pastel at all.
Most of the pictures in this book were created on Pastelmat and I enjoy
using it because it will take a lot of pastel and repeated work. It grips the
pastel well and makes blending with a finger, shaper or blender easy. I
find that pastel marks on this surface don't smudge or move as much
as on other surfaces.

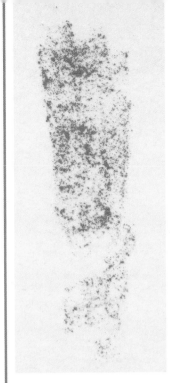

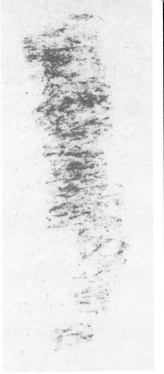

240-grade Sanded Paper
This is the roughest paper available. It resembles fine sandpaper or emery paper.

800-grade Sanded Paper
In comparison, this is far less rough than 240-grade. Between 240 and 800 are grades of varying roughness.

Black Velour
Velour comes in a variety of colours and is extremely soft – like fabric – making softening and blending easy.

Mi Tientes Touch
A firm, textured, card-like paper, this is also available in other colours.

Using different textures

All these popular papers (and more) are good for pastel work, but each has different qualities to suit a particular way of working. I like them all, and will use them to create different effects.

Canson Mi Tientes, front
This has a defined pattern, which can be filled by blending.

Canson Mi Tientes, back
This has a smoother surface, allowing more precision.

Somerset Velvet
This is a slightly textured, reasonably thick paper.

Pastelmat
A surprisingly smooth paper-like card, which is very robust.

Using coloured papers

Pastel papers come in a variety of colours and if you wish, you can use this to great effect in your work, by letting some of the colour show in the picture. Match your paper colour to your subject matter: here I've allowed soft yellows and browns to show through in beach scenes, and used an almost black paper for the basis of an atmospheric woodland scene. If you don't have coloured paper to hand, you can still use the same technique and create a snow painting on white paper, for example. I don't always leave areas of the paper showing, but it can really help to create a mood or atmosphere.

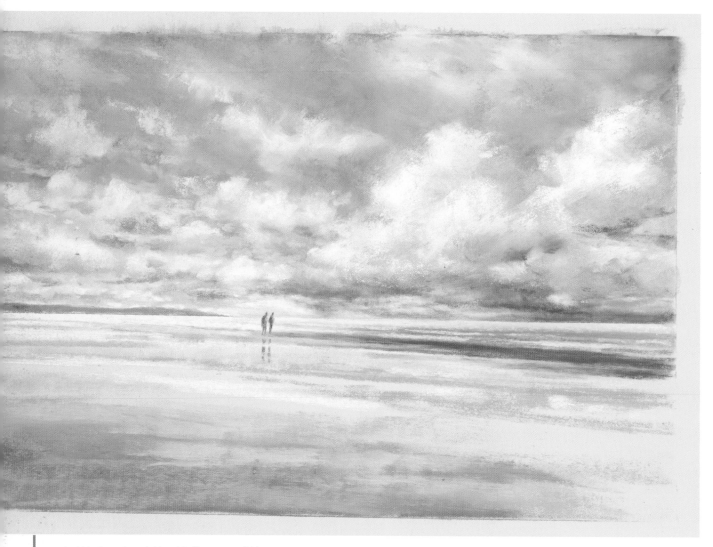

In this beach painting I left areas of the paper showing to create some of the sand and clouds. Think carefully about how you create these areas of negative space: the areas of paper showing on the beach are relatively large and made to look smooth and flat, to reflect the subject matter, while the areas left in the clouds are much more broken up.

In the woodland scene, right, the almost black colour of the paper meant that quite a number of areas within the painting didn't need covering with pastel and it gave me a good shadowy base on which to work.

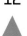

In this painting of Bigbury Beach, Devon, I left some relatively large, horizontal expanses of the brown paper visible for the deep colour of the wet sand.

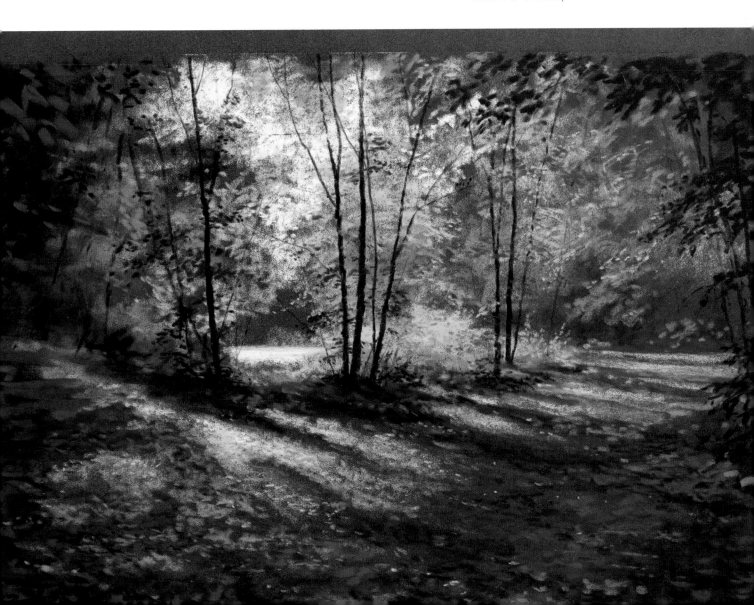

Tools and equipment

Pastel shaper

Pastel shapers, or blenders, are very useful for softening areas or lines of pastel within a picture. I usually use my fingers for large areas, but a shaper is ideal for small areas where fingers might be too clumsy. You can get pastel shapers with different tips for a variety of techniques or strokes.

Pencil sharpener

A pencil sharpener is useful for keeping a nice sharp point on pastel pencils. If you want a longer, sharper point I would recommend using a very sharp scalpel or craft knife, although rubbing gently on light sandpaper or emery board can also keep pencil points sharp.

Masking tape

Masking tape, or framing tape, is not only good for holding the paper on to a board and masking areas you want to remain pastel-free. but also for removing small amounts of excess, loosened pastel: don't blow it, stick the tape on it, press lightly and remove.

Boards

I use a variety of boards to support my work, but anything smooth and firm, preferably light-weight, will do to stick your paper to.

Cloths

A damp rag, dishcloth or moist kitchen roll is handy for keeping your hands clean.

Sticking putty

This can be used to remove chalk pastel: if you need to remove pastel from a very tiny area, fashion the putty into a point before use.

Crystal paper

Protects finished pastel work – attach with masking tape. If you are careful, you can stack work that has crystal paper covering it.

Ruler

A ruler not only enables straight lines to be drawn, but can be used to rest your hand on when working above pastel that might otherwise be smudged.

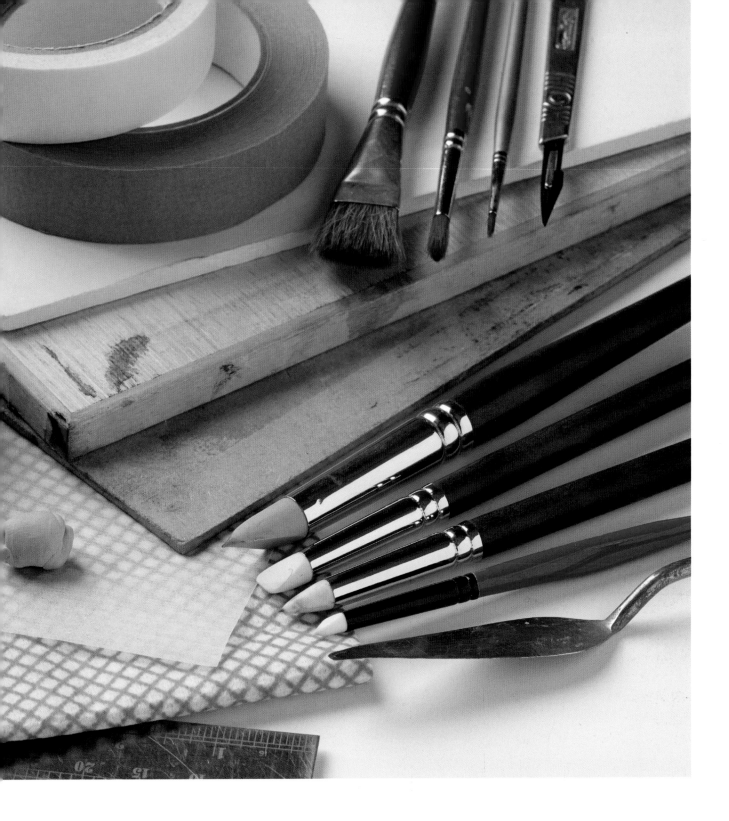

Fixative

All aerosol fixatives I've come across will darken pastel work, and it can often make colours far too vivid, removing any subtlety. While this is all right for some, I rarely use it on my own finished paintings. However, it can be very useful in between stages, particularly if the paper won't accept any more pastel, as the fixative creates a new 'surface' to grip subsequent work.

Alcohol

Isopropyl (alcohol) is an excellent addition to your pastel toolkit. When applied thinly with a brush, it can be used as a fixative, giving a new working surface once dry. I often use it when 'underpainting' with a brush to create a painterly effect, or when an area isn't working well and needs re-doing (see page 31). As you can apply it with any size brush you like it can be excellent for precision work in small areas.

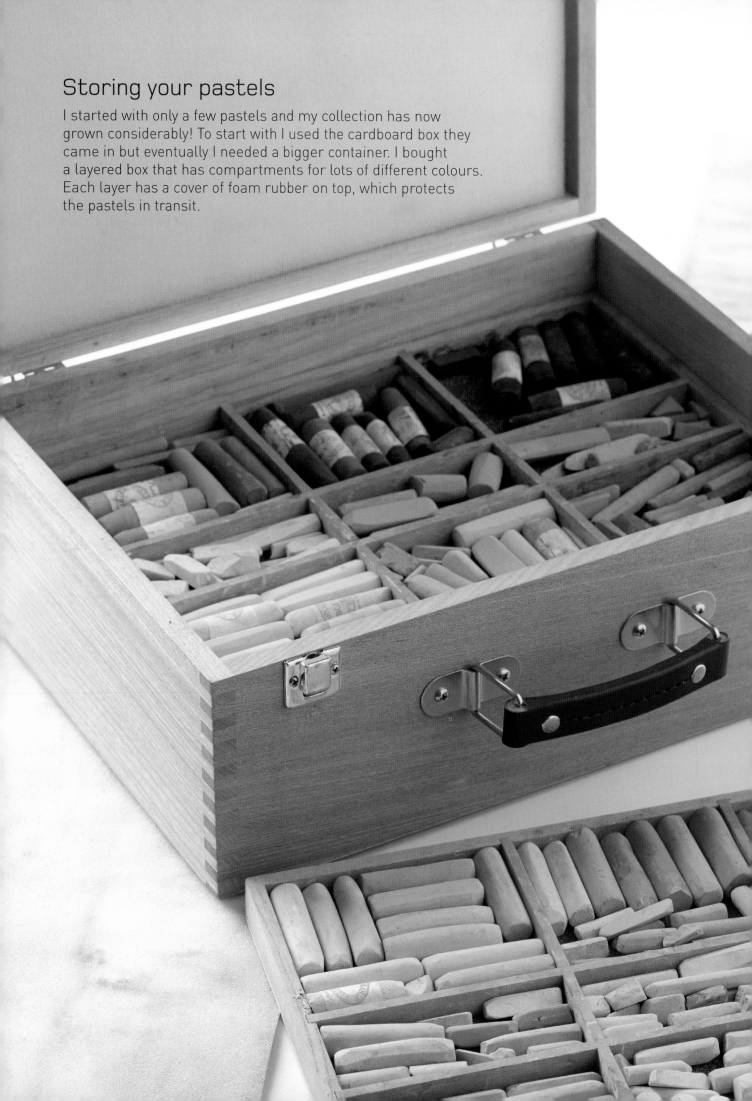

Storing your pastels

I started with only a few pastels and my collection has now
grown considerably! To start with I used the cardboard box they
came in but eventually I needed a bigger container. I bought
a layered box that has compartments for lots of different colours.
Each layer has a cover of foam rubber on top, which protects
the pastels in transit.

Mounting and framing

For me this is so important. Presentation makes such a difference and if a painting is for sale, the mount and frame can help or hinder success. I like to use what look like double mounts on most of my work, but they are in fact triple mounts. The third mount is not visible, as it is set back behind the double mount, creating a gap between the painting and the double mount. This is so that if any bits of pastel fall from the painting, particularly in transit, they fall down the back of the double mount, rather than collecting at the bottom of the frame. Never place a framed pastel picture face down in case any dust falls on to the glass.

I like to choose mounts in light and delicate tones, so that they showcase the colours of the painting in the best light and create a harmony between them. Similarly, a frame is important but it should not be too fancy – again, it should complement the work inside. When someone looks at my painting I don't really want to hear them say, 'what a beautiful frame!'

The small gap between the double mount and the painting can be clearly seen at this angle.

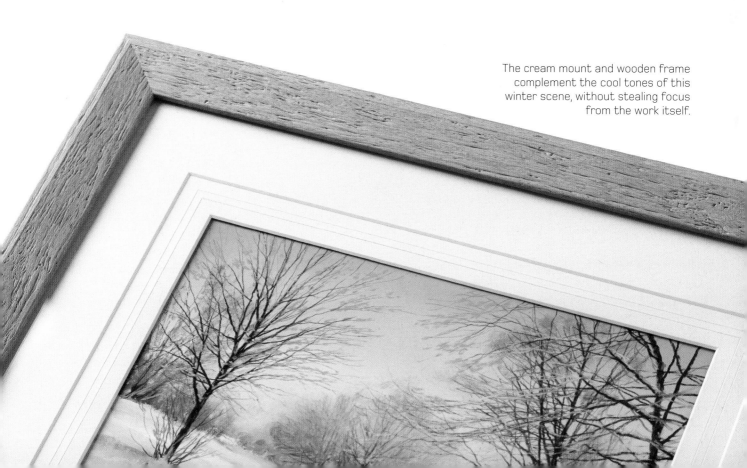

The cream mount and wooden frame complement the cool tones of this winter scene, without stealing focus from the work itself.

Mark-making

There are many ways of applying a pastel stick, and you can create a number of useful effects. The size of the pastel will determine the size of mark you make: the tip will give smaller marks, whether linear or dotted, while the body or side of the pastel will cover large areas more quickly.

Using the tip of the pastel

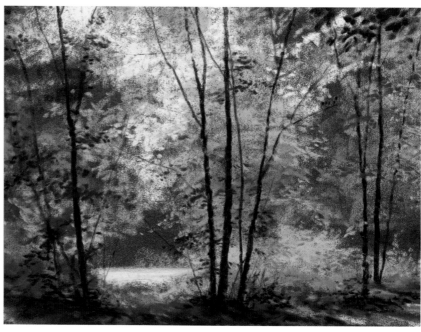

The tip will be used where more precision is required. You can achieve different thicknesses by applying different amounts of pressure. You will get a finer line with only slight pressure and thicker lines or marks with greater pressure.

Stippling

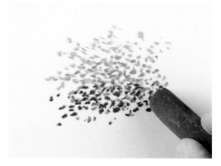

Little 'blobs' of colour can suggest so much. This effect is particularly helpful for foliage, leaves, stones, shingle or shale, creating a 'pointillist' effect.

Using the edge of the pastel

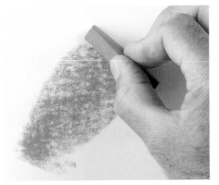

Using the whole side or body of the pastel can cover a larger area than just using the tip. You can achieve interesting shapes by dragging the pastel in different directions, and by using sharp edges to create defined lines.

Tip: creating sharp edges

When pastels are new, the body may be round or square. If your pastels are round, you can create a sharp edge to the body by using the same part of the pastel to cover an area, then as it wears down, turn it round and do the same until a corner or edge appears. That long edge can be very useful for making fine lines for grasses (see above), by lightly tapping the length of the pastel stick on to the paper surface. You may also be able to make such slender lines with the tip, if you can get it fine enough.

Flaking

This technique can be particularly useful when you want little hints or flecks of pastel to stand out, such as leaves on a distant branch or splashes of water, as seen in the waterfall below.

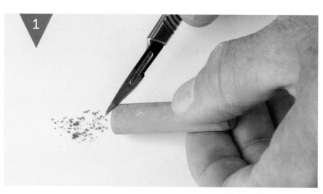

1. Scrape a knife or a hard-edged implement gently down the side or tip of a pastel stick, over the area to be worked, so little crumbs of pastel appear on the paper surface.

2. Use a palette knife or spoon to press the bits into the paper.

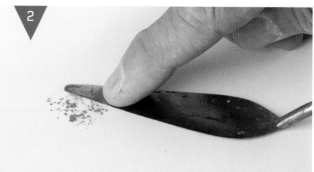

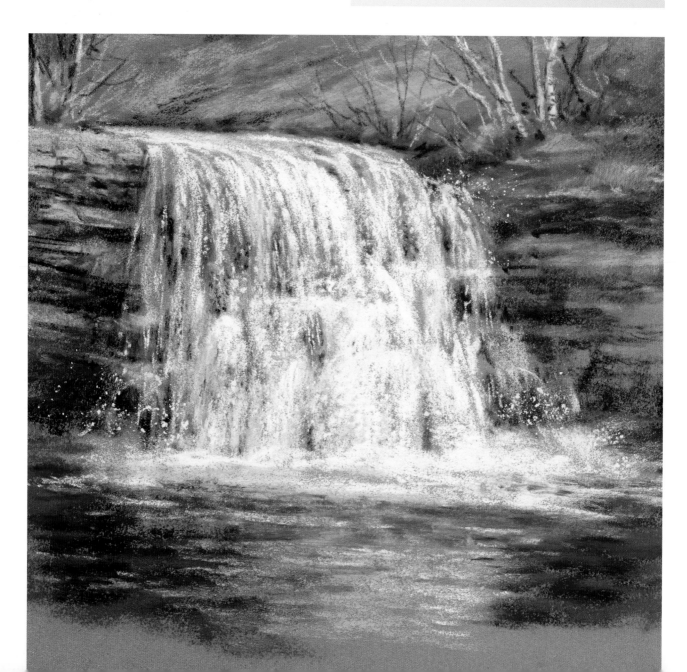

Using a pastel shaper

Made of flexible plastic, pastel shapers come in different sizes and shapes. I like the ones that have a sharp point and a definite edge. You can use them to blend or neaten small or precise areas of your work; you can also 'lift' a little pastel from one area and put it elsewhere, or touch the shaper on to the pastel and transfer some on to the paper.

Softening colours together

If your finger is too wide to use on the area to be softened, use the tip and the edge of the shaper to rub the colours together until they blend. Here, two colours were drawn next to each other, as if to create a tree trunk or branch. The blend of light to dark creates the soft illusion of a curved shape.

Making neat edges

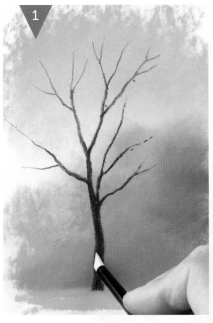
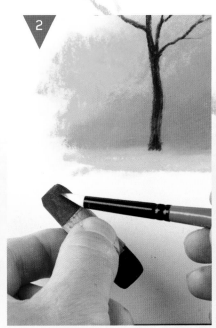
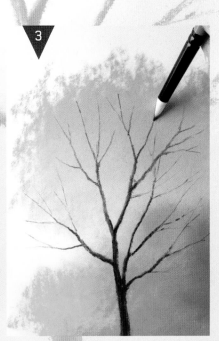

1. If a line of pastel is not defined enough and you need a bolder, crisper edge, use the shaper to ease the pastel gently into position.

2. If you need to apply some extra colour, touch the shaper on to the pastel to pick up some of the powder – a bit like dipping a brush into paint.

3. Use the shaper like a pencil to draw in additional fine lines: you will be able to create much more delicate, defined lines than if using a pastel stick.

Masking-tape techniques

Masking tape is very handy for a variety of purposes, particularly for drawing straight edges and lines. Because it is relatively low-tack, it can be applied gently to your work without fear that it will lift off all your pastel.

Creating straight edges

1. Create your sky (for tips on creating clouds see pages 54–57). Carefully put masking tape down underneath, making sure it is straight, and press down firmly. Use your finger to blend the pastel right down to the tape.

3. When you are happy that your sea is finished, carefully peel away the masking tape to reveal a crisp horizon.

2. Lift the tape and move it up, so that the bottom edge of the tape now sits slightly above the straight line created in step 1. Create the sea, allowing it to overlap the bottom edge of the tape a little, making sure that the sea colours cover well.

4. If the revealed edge is too sharp, gently run a clean finger horizontally over the horizon to soften a little.

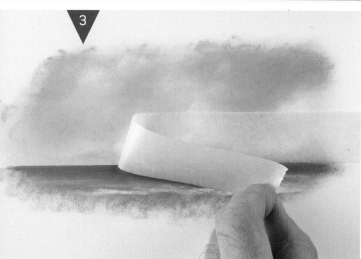

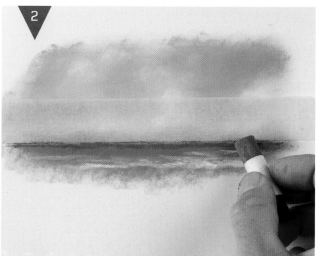

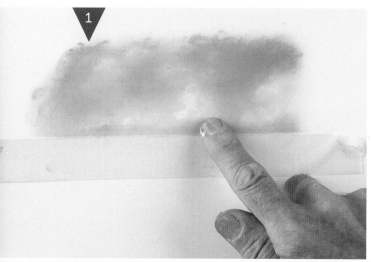

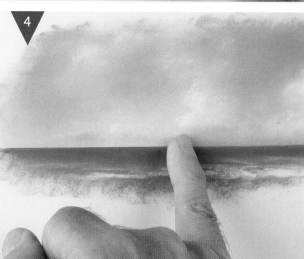

Creating straight lines

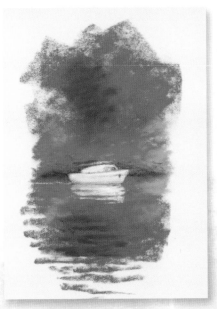

For the mast of the boat I wanted to use a soft pastel, as this covers better than a hard pastel and is often brighter, but doesn't always produce a fine enough line.

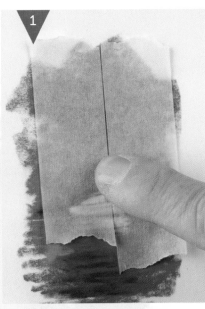

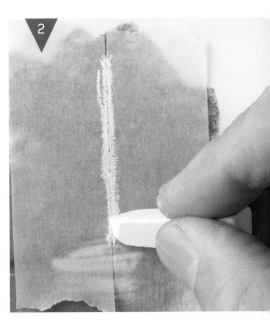

1. Place two strips of masking tape adjacent to each other, leaving a very fine gap between them where you want your mast – or other fine, straight line – pressing down well.

2. Use plenty of soft white pastel to cover the entire mast evenly.

3. Carefully remove the strips of tape, leaving a nice hard, straight line for the mast.

4. Neaten the line with a white pastel pencil if necessary. To finish, use the pastel pencil to create a wobbly reflection on the surface of the water.

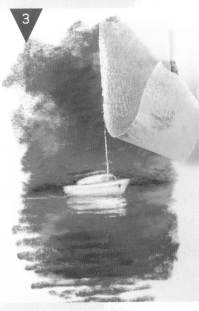

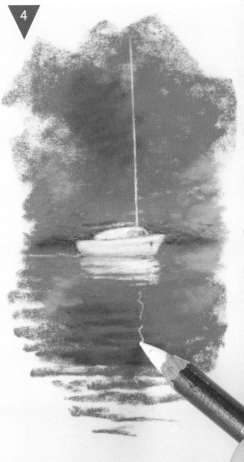

Using pastel pencils

Pastel pencils allow you to achieve much greater precision than a pastel stick. If you are using your pastel pencil to add finishing touches to a painting, practise first on a spare piece of paper, so that you are confident.

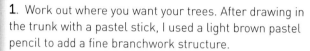
Tip: perfect pressure
Press only lightly to start with – if your lines aren't clear enough, apply a bit more pressure.

Creating definition

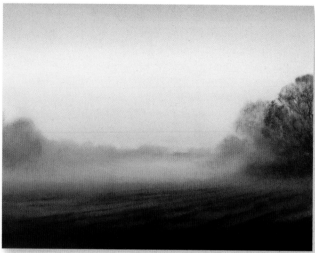

The early morning mist hovers over a newly ploughed field. I have decided that some trees in the distance would add a bit more interest, but pastel sticks might not be subtle or fine enough for the softness of the picture.

1. Work out where you want your trees. After drawing in the trunk with a pastel stick, I used a light brown pastel pencil to add a fine branchwork structure.

2. Decide whether your painting needs further work, such as additional trees. Don't feel that you have to complete one before moving on to the next though – you can always start a few and work them all at the same time, to make sure you are happy with the overall balance.

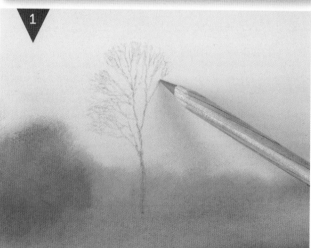

Here, pastel pencils allowed me to create some fine branches and twigs, and some detail in the figures (see page 96 for the full painting).

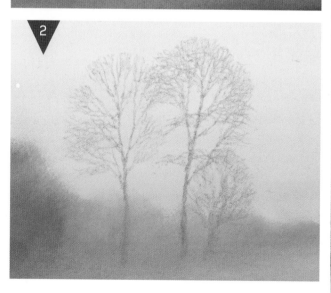

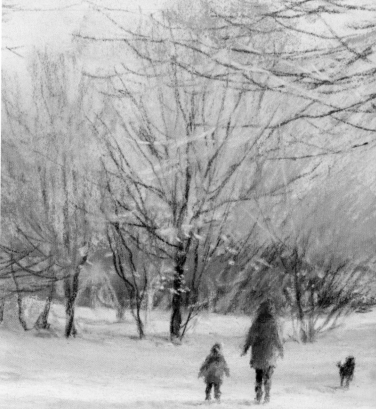

Correcting mistakes

Everyone makes mistakes from time to time – the most important thing is knowing how to overcome them. There are different ways of doing this, depending on circumstances and preference. A putty eraser can remove some pastel but for a larger area more drastic action may be required.

1. When you put pastel on paper, it fills the tiny crevices in the surface. Even if it has been heavily rubbed in, most of it can be easily removed with a brush.

2. I don't blow the removed pastel dust, but prefer to apply masking tape to pick it up. Press it on, then dispose of it, using more than one piece of tape if necessary.

Removing excess powder

Using alcohol

Even if a lot of pastel has been brushed off, overlaying the area with another colour can be difficult because you may pick up the colour underneath without wanting to, and some may show through.

Using alcohol will seal the surface so that you can work over the top without picking up the colour. Alcohol-based spray fixatives can be used, but in smaller areas I use a brush with alcohol from a bottle. Alcohol darkens the colours, which is why I generally don't use it as a final fixative.

1. Paint alcohol over the specific area with a brush, then leave to dry.

2. Apply your new colour: here you can see that even light colours easily cover fixed darker colours.

3. Even blending with a finger doesn't disturb the earlier fixed colour.

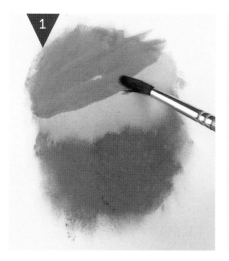

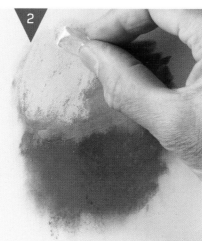

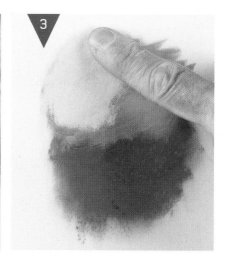

Blending

Blending colours together roughly or smoothly can produce pleasing effects, and there are times when you will need to do both. Blending can be done with a part of the hand, a pastel shaper or blender, with tissue, or with another colour.

Tip: blending

Any part of the hand can be used for blending, but take care if you're wearing jewellery.

Rough blending

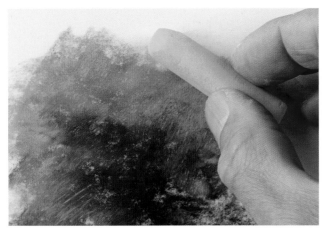

A dark green was initially laid over the paper, then the yellow pastel was lightly dragged over so that it just creates a slightly rough effect. For a rough blend leave this as is, or soften slightly with a finger using very light pressure.

Smooth blending

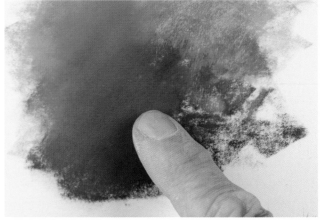

A dark green base was laid down first, then yellow was applied on top. Rub firmly with a finger or implement until a smooth blend is achieved. See below for suggested techniques.

Smooth blending techniques

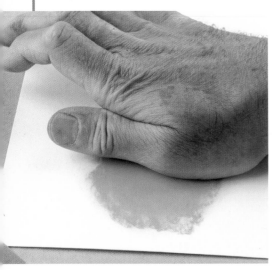

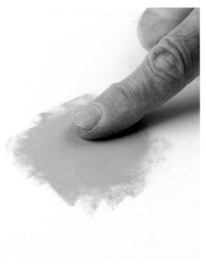

The palm of the hand and base of the thumb can smooth a fairly large area quickly.

Fingers can give a precise blend in smaller areas.

The side of the hand can smooth quickly, firmly and efficiently.

Adding light and dark

Generally it's easier to put lighter tones over darker tones, but a lot depends on quantity. If too many darks have already been applied, strong brightness may not be possible without applying fixative or isopropyl alcohol beforehand. The same can be said if too many coats of light have been applied before you want to darken an area. In both the examples below, I used the same blue as a starting point to show what effects can be achieved.

Tip: quick fix
If you find that you are not able to lighten or darken an area as much as you want, apply a thin layer of isopropyl alcohol to fix the pastel, then continue to add further colour after it has dried (see page 25).

Lightening

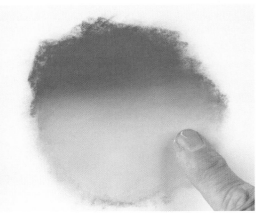 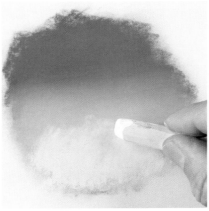 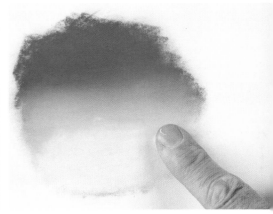

Add white to the lower part of the blue and blend it in smoothly. The number of times you can repeat this process depends upon how much pastel has been applied previously.

Darkening

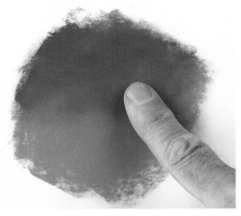

Add a deeper blue to the upper part and blend it in using a finger. To darken further still, either repeat with the same colour or use an even darker colour than before.

Overlaying colour

Try this simple landscape picture to practise your application and blending of colour.

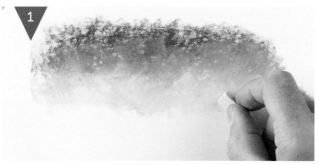

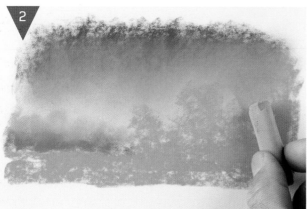

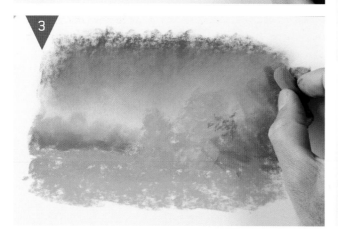

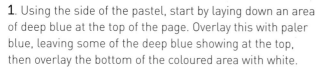

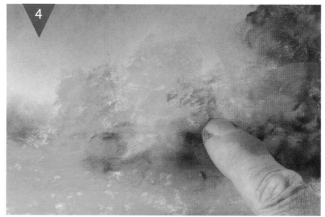

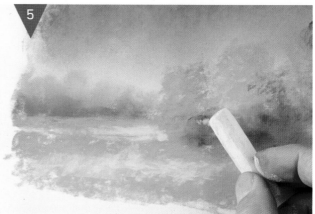

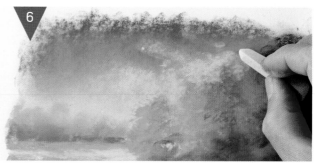

1. Using the side of the pastel, start by laying down an area of deep blue at the top of the page. Overlay this with paler blue, leaving some of the deep blue showing at the top, then overlay the bottom of the coloured area with white.

2. Blend this with your fingers to create a smooth sky that softens gradually from light to dark. To create a hazy background, apply some pale and then deep purple to the bottom left of the sky and soften gently with your fingers. To create the foreground and the trees, overlay broad strokes of mid-green using the side of the pastel.

3. To create a sense of depth, overlay this green area with a brighter green, bringing the colour further down towards the bottom of the picture, but leaving some of the mid-green showing through. Then add a dark green to the right-hand tree.

4. Soften these areas a little using a fingertip.

5. Continue to build up the layers of colour: apply areas of deep yellow at the bottom of the foreground and along the horizon line, and apply a pale cream with the pastel tip.

6. To create a suggestion of cloud, use the tip of a pale blue pastel to add colour above the trees.

28

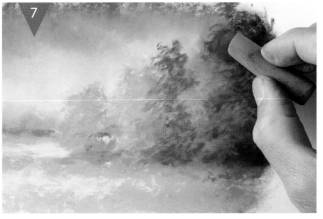

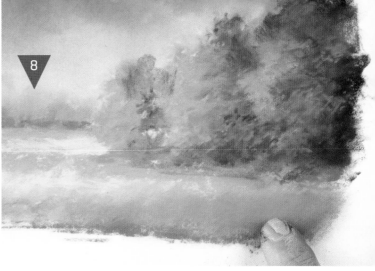

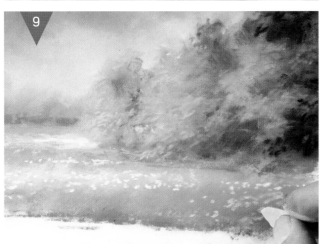

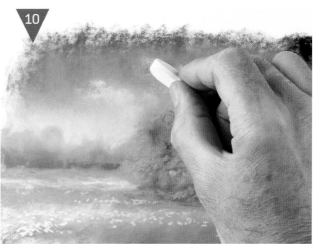

7. Continue to add dark and bright green tones to the trees and the ground around them to create both shadows and highlights.

9. Apply a small amount of pale blue-grey extending out from the left of the trees to create a soft shadow. Add yellow and white flowers by dotting here and there with the tip of the pastel, but not do not soften or blend in.

8. Overlay a deep golden brown at the bottom of the foreground. It's up to you how much you blend the colours of the foreground and the trees: if you want to soften a little, just touch lightly with your finger or a shaper.

10. Use the tip of a white pastel to apply some soft highlights to the clouds for added brightness.

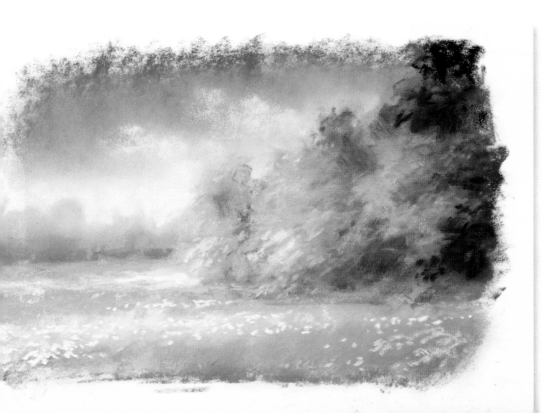

As a finishing touch, little areas in the brighter, left-hand trees were overlaid with white to create the illusion of dramatic sunlight on the leaves.

Naturalising vivid colours

Some colours can be a bit garish or vivid, such as the green, orange and violet shown below – and you might struggle to create a natural-looking landscape using these colours alone. However, overlaying them with other colours can calm them down, making them more natural.

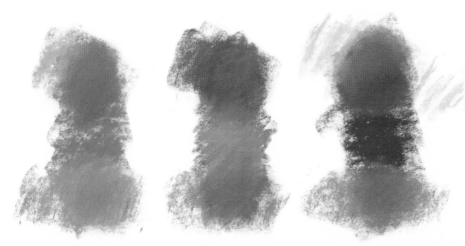

The green, orange, and violet were overlaid with other colours (at the top) and grey (at the bottom), and then blended together with a finger to give softer versions of the same colour.

Naturalising exercise

In this picture of a tree, the green used initially (see below) looks a bit vivid and unrealistic. To remedy this, I overlaid yellows along with paler and darker greens (see right) to create a richer, more natural-looking colour.

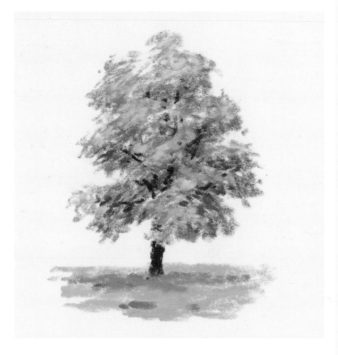

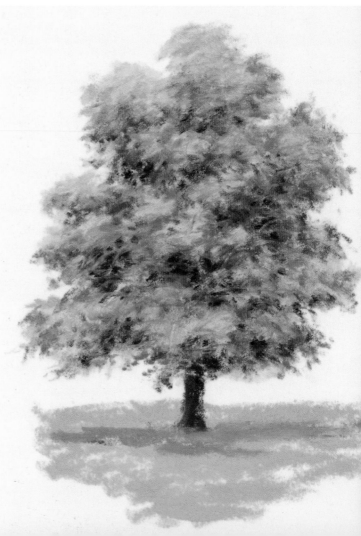

Underpainting

A brush dipped in alcohol moves the pastel around like paint and can create beautiful wash effects. When dry, it seals the pastel into the paper and won't rub off. This is such great fun and gives your initial base colours a painted effect, which you can then work into.

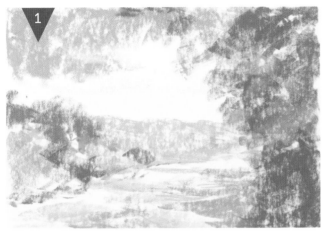

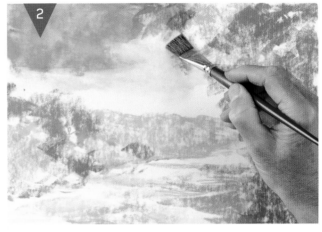

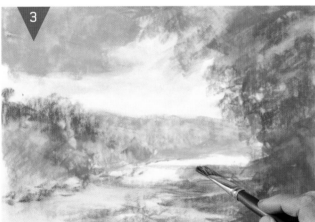

1. Sketch out the rough areas of colour in your design, using light layers, applied using the body of the pastel.

2. With a small amount of alcohol on your brush, wash over each of your coloured areas, using the brush to soften and 'paint' with the pastel.

3. Continue working down the page until all your coloured areas are 'painted'.

Tip: changing colour

When going from a dark colour to a light colour, be sure to clean the brush first. When the alcohol has dried, you can go over with pastel and repeat if necessary.

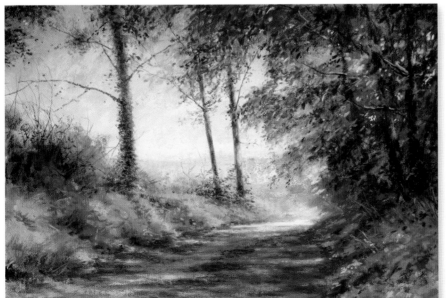

The Road to Le Roc is one of my favourite pastel pictures, because of this underlying painterly style. This technique can create some lovely rich areas of colour and is an excellent tool to have up your sleeve.

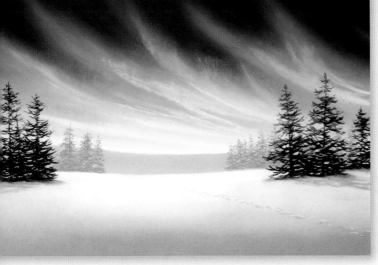

Northern Lights

Although fairly simple, this is a very effective scene: streaks of light move across a wintry sky, and distant pale trees contrast with the powerful black foreground trees. This is a great picture to start out with as you will incorporate lots of smooth blending and also use precision to create the trees.

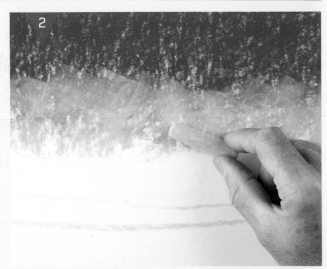

Colours needed

Pale grey, dark blue, pale blue, pale green, yellow, mid-blue, white, black and dark grey pastels.

1. With pale grey, draw a gently waving line from one side to the other for the horizon – just over halfway down – then add another line below that (use the finished piece above for reference). Colour the top third of the paper using the side or edge of a dark blue pastel, being careful not to put too much on initially. Don't 'fill in' the paper with the pastel; you will use your fingers to work it into the paper at a later stage.

2. Overlay the lower part of the dark blue with the side of the pale blue pastel; apply the pastel relatively lightly.

3. Overlay pale green on to the lower part of the pale blue using the side of the pastel. Use the pastel to create a light swooping mark up into the blue.

4. Use the side of the yellow pastel to overlay further colour on top of and below the lower part of the pale green. You will be fairly close to your horizon line now.

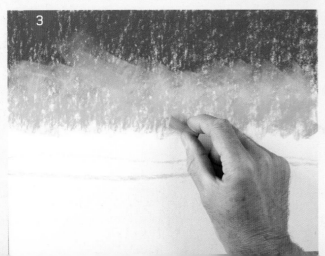

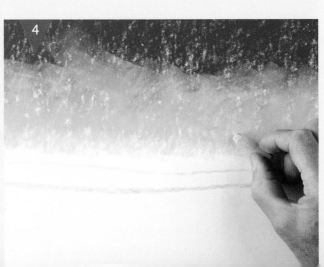

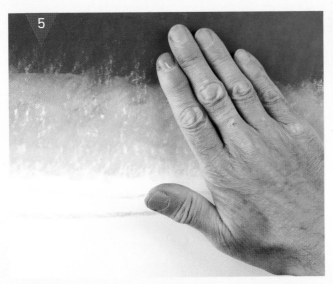

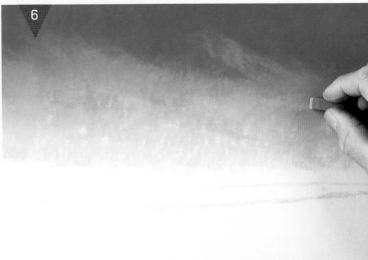

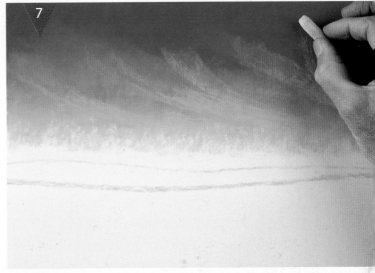

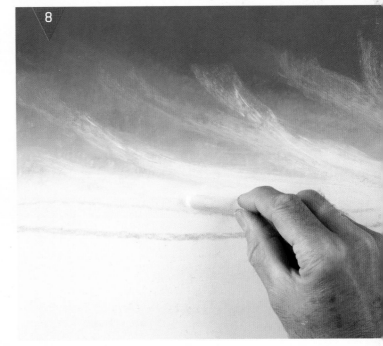

Tip: clean fingers

When blending the lighter colours, make sure your fingers are relatively clean.

5. Use your fingers to blend the blues into the paper, filling in any gaps and creating a smooth blend of colour.

6. To build up a greater richness in the sky, use the side of your mid-blue pastel to create swooping lines across the sky that will form the basis of the northern lights.

7. Using yellow, drag the side of the pastel in the direction of the streaks of light, creating them across the whole width of the sky. Be bold here: remember that the colours will soften when you blend them later on.

8. Use the white pastel in the same way as the yellow in step 7, creating further swooping lines underneath and amongst the yellow. Work the white pastel down as far as the horizon line.

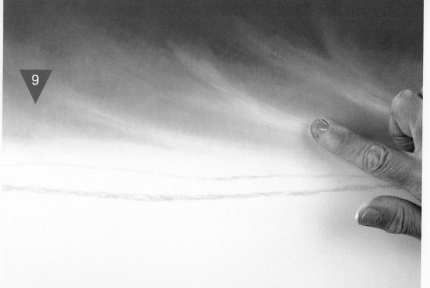

9. Use a clean finger – or fingers – to blend all the colours in the direction of the streaks of light.

10. To create a dark contrast in the sky, put a gentle application of black on, on top of the blue, between the yellow-green streaks at the top.

11. Use a finger to blend the black into the blue, following the same direction of the streaks of light.

12. With your sky complete, it's now time to work on the foreground. Apply a pale grey – or overlay a dark grey with white – in between the two horizon lines you drew in step 1. Soften this colour into the paper using a finger to create an even surface.

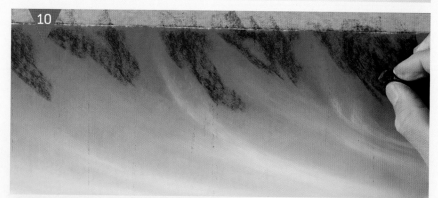

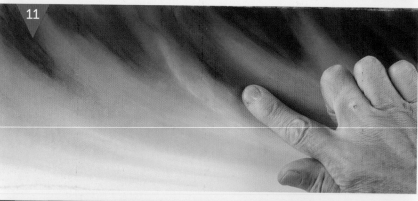

Tip: keep it clean
After using dark colours, wipe your hands clean!

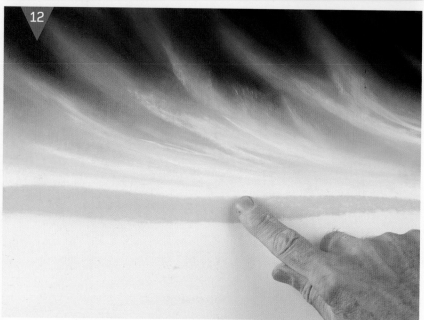

13. Soften the top of the horizon line with your finger.

14. Put pale blue down under the pale grey using the edge of the pastel, and take it almost to the bottom of the paper. Leave a white space free in the centre, directly under the horizon.

15. Overlay the lower pale blue with a dark grey, using the edge of the pastel to create a light, even coverage.

16. Blend the pale blue and grey together with your fingers to create a smooth, even coverage. Overlay the top of the pale blue with white and blend again, using your fingers.

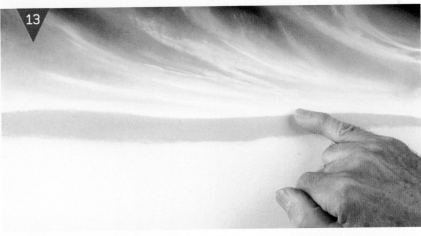

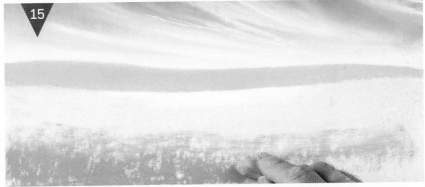

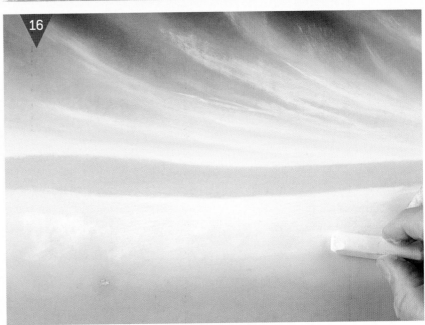

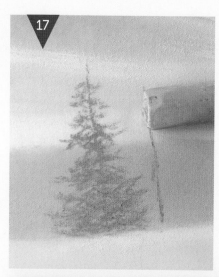

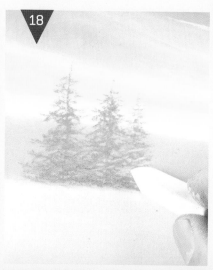

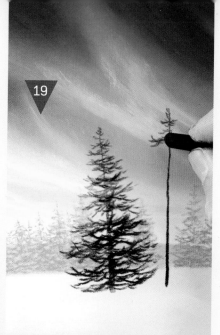

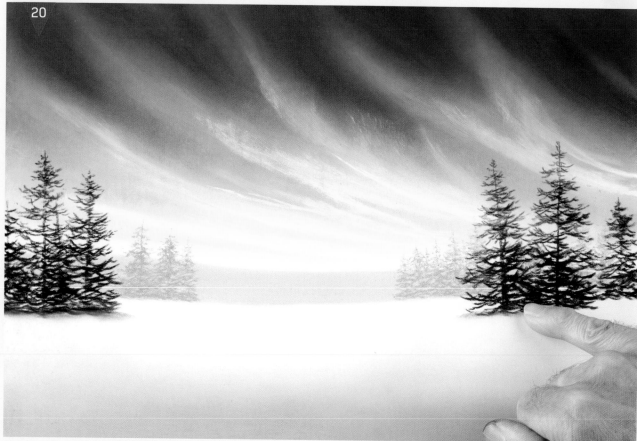

17. Use the tip of a mid-grey pastel to draw in your distant trees lightly. Draw in the trunks first. When creating the branches, start at the top of each tree and work down towards the ground. Note the irregular shape of the branches. Be gentle and don't blend or soften. You will need to create trees on both sides of the horizon, leaving the centre clear.

18. To create snow on a few of the branches, use the tip of the white pastel and don't soften or blend.

19. Very gently draw the black trees in the same way, making very small branches at the top, and wider branches lower down the tree. These trees are lower down than the grey trees. If they become too solid, add a little snow to the branches with pale grey. (See the finished picture on pages 38–39 for guidance on where to place them.)

20. Using your little finger, gently smudge the bottom of each black tree sideways. This helps to 'ground' the trees in the snow.

36

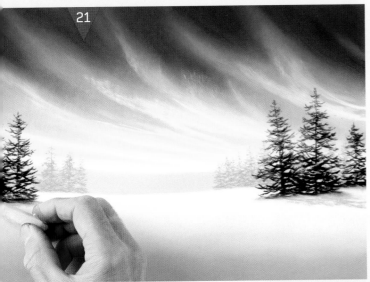

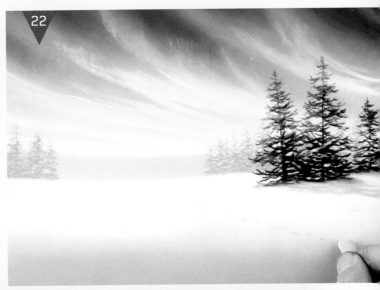

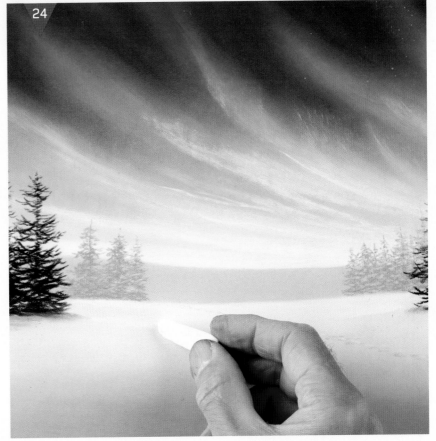

21. Create a suggestion of soft shadow under the black trees by drawing in small broken lines using the tip of a pale or mid-grey pastel. Soften them slightly with a finger, but do not blend in.

22. From the centre of the horizon down to the bottom-right corner create a line of footprints using the tip of the pale or mid-grey pastel, where the snow is white or very pale.

23. If the footprints stand out too much, soften them by gently tapping with a finger or using a pastel shaper.

24. Add a few touches of white to the footsteps created in step 22, to give them a few highlights. Elsewhere in the picture, add a few gentle strokes of white where the snow is darker to add a little texture and light here and there.

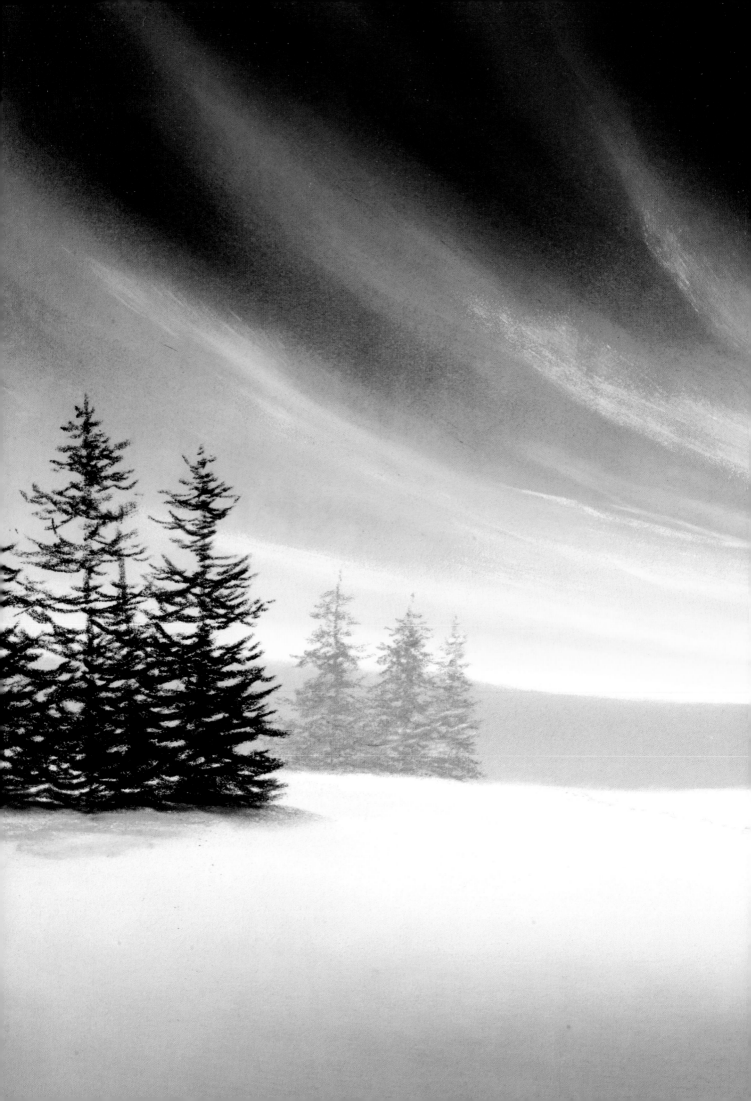

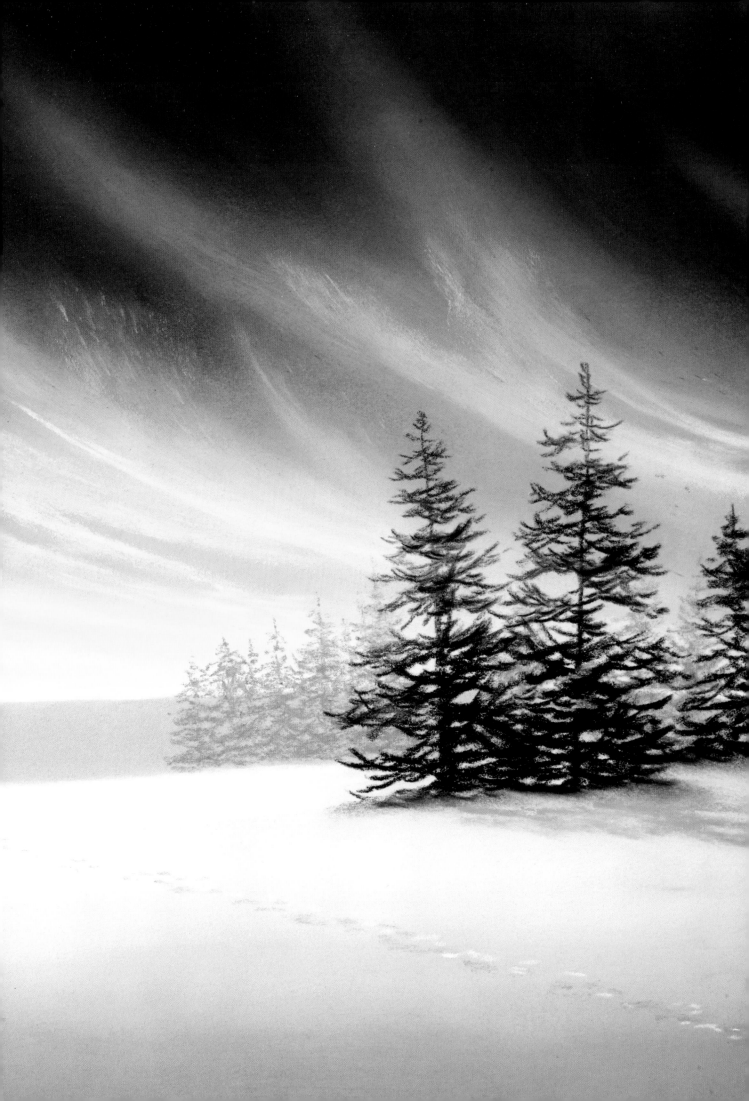

Colour and tone

Colour ranges

Having a good range of pastel colours gives you great freedom of variation, and can bring real depth to your work. If you are new to pastels, you may only have a few colours to start with, which you can add to over time. But don't worry if you only have a basic selection: bear in mind that many colours and tones can be created by overlaying, which will greatly increase your range. I find greys in particular very useful for naturalising bright colours to achieve subtlety. And having some bright colours and some dark colours will enable you to have a good mixture of the two when overlaying. A range of tonal values within colours is important also, as you can see from the colour ranges, shown left. Practise mixing and blending your existing colours to see what variations you can create.

Tonal ranges

A good range of tones from white to black should be a key component of your pastel toolkit. I think that in many ways, tone is more important than colour, because things are defined by their tonal relation to each other: it's how things stand out.

In the picture of Lake Windermere, right, I used a wide tonal range but only a limited colour range. From the lightness of the sky to the black trees, the whites, greys and blacks create a moody and atmospheric scene, which is no less effective for its limited range of colours.

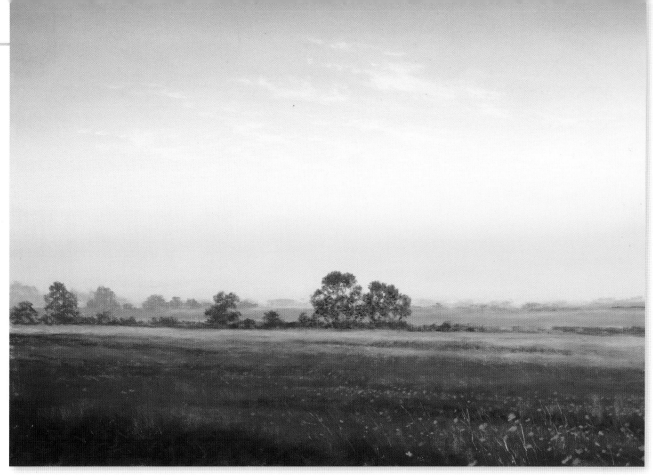

This is the view from my studio. From the red poppies and yellow fields to the green trees and blue-orange sky it contains a reasonably good range of colours. What brings this piece to life is that there is also a good range of tones, from the palest sky colours to the darkest foreground colours.

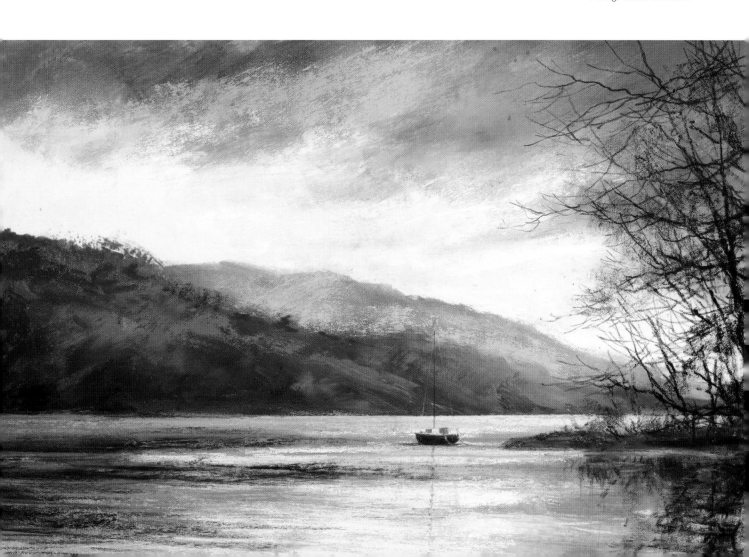

Creating light at different times of day

It is a useful exercise to study how light can affect the same subject or scene at different times of the day. By adjusting the range of colour and tone used you can vary the mood of a piece enormously. Of the two paintings below, the top one was created in the morning, and the bottom one created late afternoon as the sun began to set. Compare how the light affects the sky and hillside in particular; one painting isn't necessarily better than the other, they are just different.

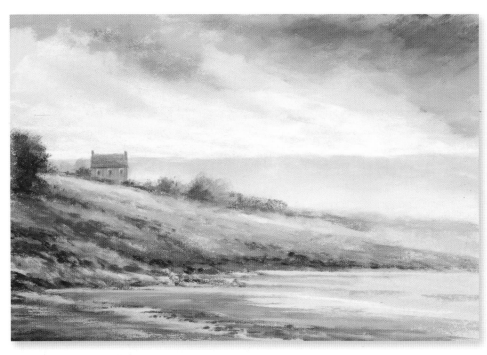

The sky here is flooded with light, with bright whites and pale purples used in contrast to the brooding clouds in the top right-hand corner.

The hillside is dappled with bright, soft colours as the morning sunshine catches it.

The smooth reflection on the water bounces back the light from the sky.

The house is easily discernable, standing out from the pale background on the light hillside. There is a fairly limited colour range but a reasonably good range of tones present throughout.

Here, we can see that the sun is setting behind the far-off hills. The use of a more colourful sky and the darkening distant hills gives a little more drama; the house is cast into shadow and is almost a silhouette.

The hillside is dark, with the soft yellows of the previous version replaced with darker browns and greens. This, along with the dark foreground, creates a more dramatic image. The more limited use of tone suggests the failing light.

The water also takes on some of the darker tones surrounding it, and is much darker and less smooth than in the previous version.

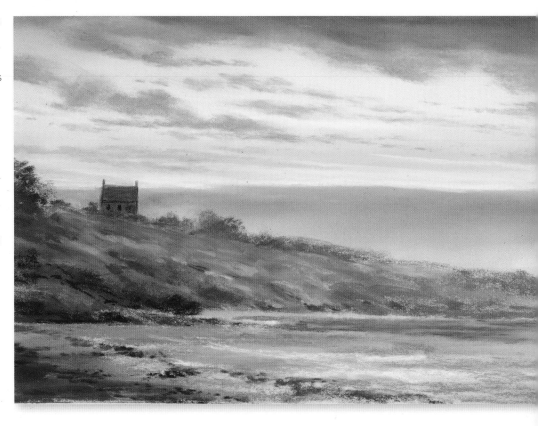

Creating mood

The mood of a picture is largely dependent upon colours and tone, and can be accentuated by greater use of both. In the first picture shown below, there is a warm, hazy harmony to the scene, but I think it is improved in the lower picture, where the darks provide more depth and emotion. The lights look brighter in this bottom picture because of the contrasting darks. Compare in particular the foreground foliage, the shadows cast by the trees and the colour of the path that cuts across the middle of the painting. For me, the moodier, darker painting is more pleasing, as it has more depth and contrast.

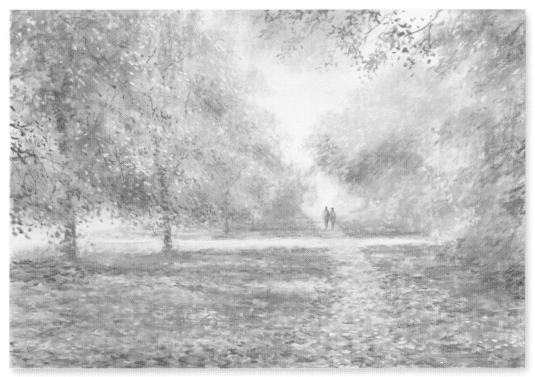

Painting using a limited range of tones can give a soft, hazy feel to a scene.

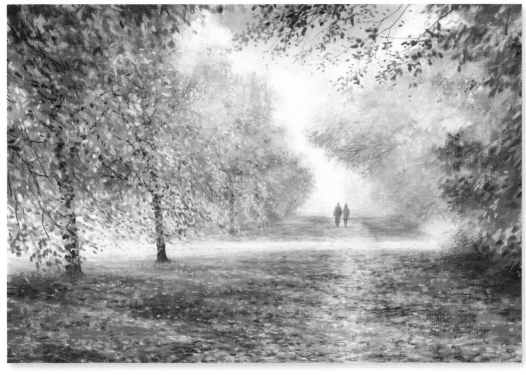

Painting using a wide range of tones helps to provide drama and depth.

43

Creating atmosphere

This is interlinked with creating light, dark and mood, because it incorporates the same principles of colour and tone. A simple subject can say so much with thoughtful use of these attributes. As we saw in the examples on the previous two pages, tweaking the colour and tone can make an enormous difference to the feel of a painting.

Atmospheric gallery

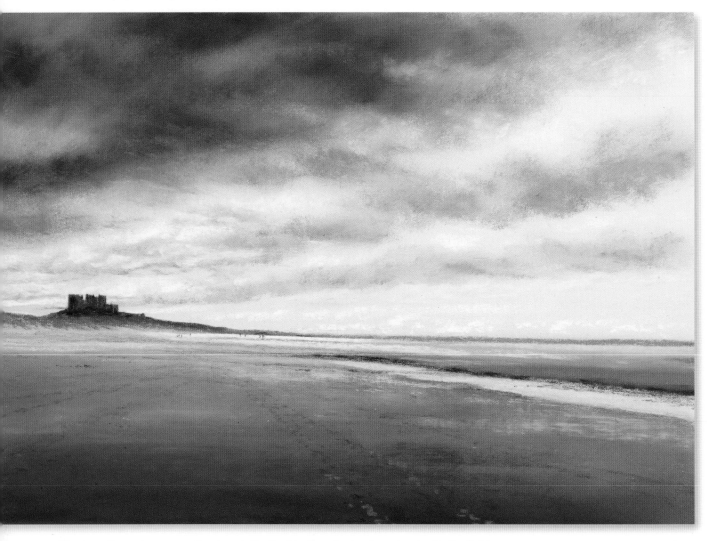

The brooding colours over Bamburgh Castle, Northumberland, contrast with the light horizon; the light strip of sand similarly provides a contrast to the dark foreground. This is a wild, beautiful coastline with vast open spaces and this is accentuated by the small scale of the castle compared with the endless stretch of beach.

These two figures on a beach convey the scale of the scene as well as the size of the forces of the natural world. A freedom and spaciousness is suggested by the relative emptiness of the scene. The bright colours used for the sky and the sand reflect the bright, blusteriness of the day.

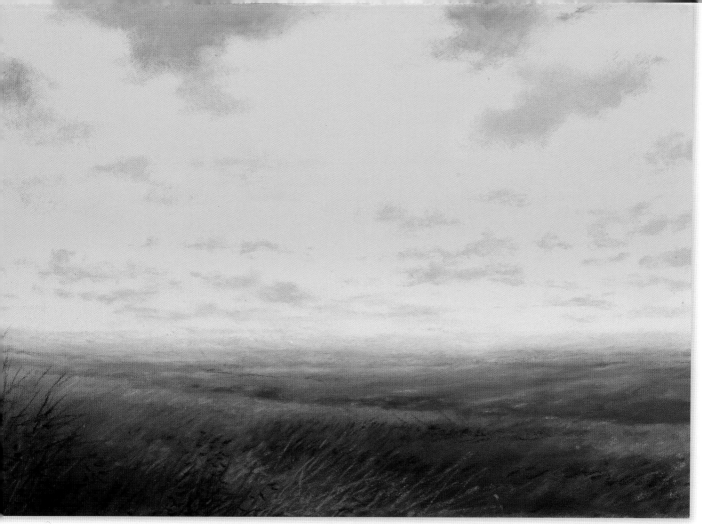

The moors at dusk provide a warm atmosphere in an otherwise wild and windy place. Now there is a stillness in the peaceful sky, an appealing glow to the grasses and a hazy calm in the far distance.

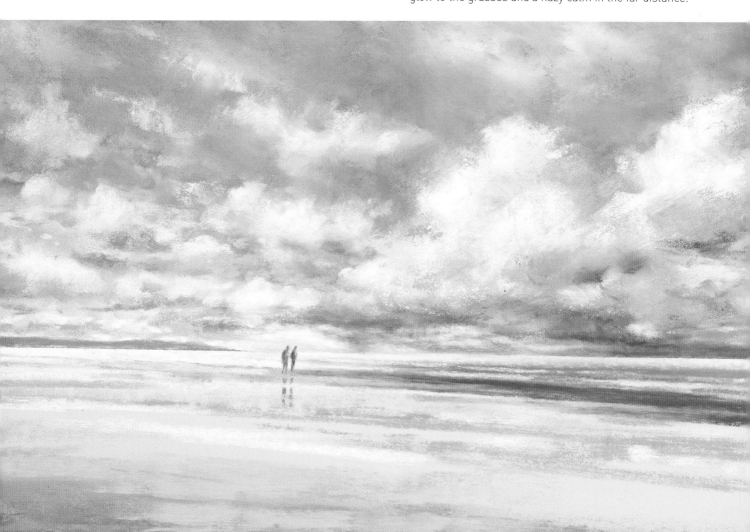

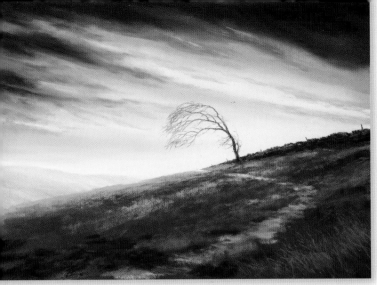

After the Storm

This atmospheric, moody scene has strong tonal contrasts and can be created with other colours if preferred. Although this was worked on an almost-black paper it could be done on any colour, and where black paper is visible, black pastel could be used instead.

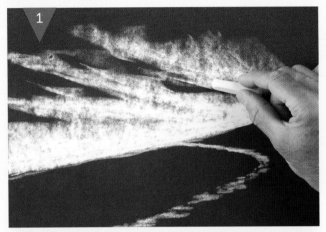

1. Using the finished piece on pages 52–53 as a guide to spacing, draw a white line diagonally to separate the sky from the land and apply some sweeping white marks into the sky using the side of the pastel. Create a path that curves across the foreground and becomes smaller as it recedes into the distance.

2. Go over parts of the white streaks with a pale yellow, then do the same with an orange colour.

3. Blend the colours together with your fingers in the direction of the light streaks.

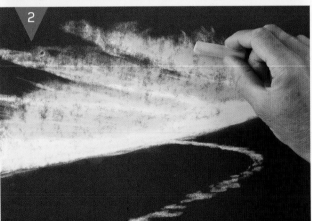

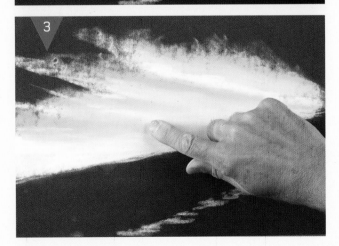

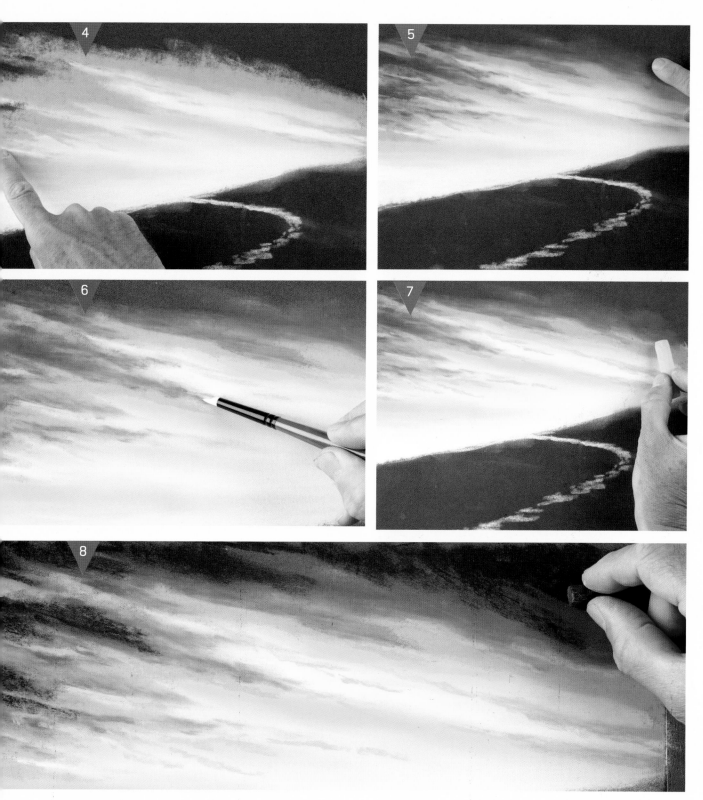

4. Above this block of colour, add in some delicate streaks of pale grey, with some overlapping the orange and yellow, then blend as before.

6. Using the pastel shaper, lift some dark grey from the top part of the picture and re-apply it lower down.

8. Apply a thin layer of black to the visible areas of paper in the sky, and blend it in with your fingers.

5. To create a smoother transition between the pastel and the dark paper, add dark grey in the same way that you added pale grey in step 4, then blend in the same direction with a finger.

7. If you feel that the overall balance has become too dark, add a few little pale orange streaks over any dark areas.

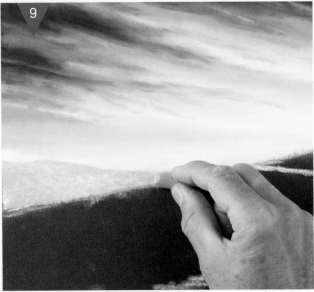

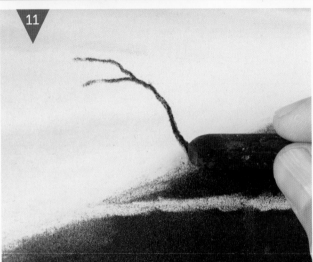

9. Use pale grey to block in some distant hills that are slightly lower down than the path. Create an organic, sightly curving line at the top, and don't apply the pastel too thickly.

10. Go over the top edge of the hills with a finger, gently softening it, then blend the rest of the grey area into the paper.

11. Using the tip of the black pastel, draw a bent, windswept tree. I found it easier to start in the sky above the path and work down towards the ground.

12. For the branches and twigs, pastel sticks are too big so use a pastel pencil, which will give you much more control. Extend out the lines drawn in step 11 to create delicate branches. Try not to press too hard.

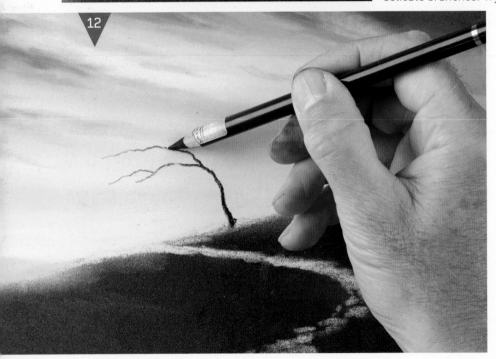

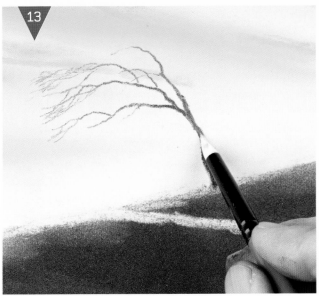

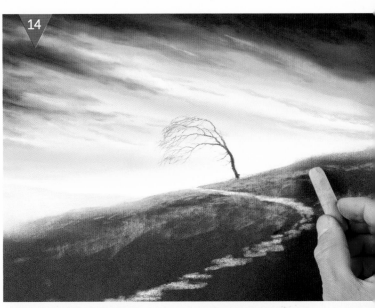

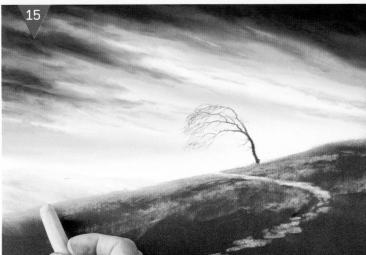

13. Continue with the pastel pencil to fill in the branch structure and create even finer sub-branches. Use the pastel shaper to go over the tree trunk, pushing it into the paper. Continue adding to the tree until you are happy – you may wish to refer to the finished painting on pages 52–53 for guidance.

14. Begin to lightly colour the moorland grasses, starting at the top of the hillside. I used yellow ochre here, but you could use raw sienna, raw umber, or any light brown.

15. Add in some touches of light green using the tip of the pastel – this will provide variation in the grasses. Remember that you can leave small areas of the paper uncovered by pastel if it's a dark coloured paper.

16. Continue to add variety by applying a few light touches of mid-green, being careful not to overdo it.

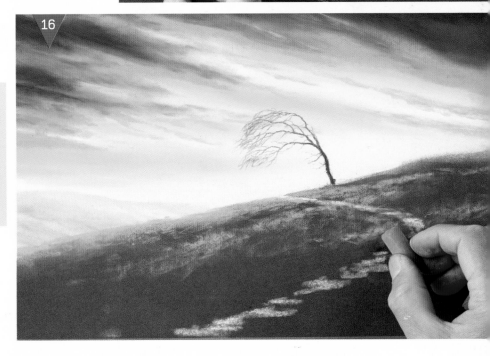

Tip: use it well

Over large areas of paper use the edge of the pastel; over small areas, use the tip. See steps 19 and 20 overleaf for other ways to apply the pastel.

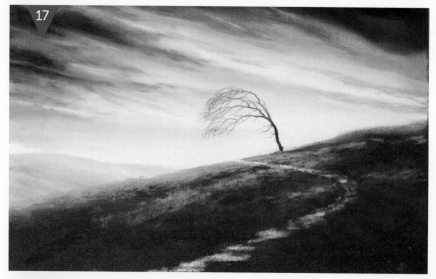

17. Continue to apply light splashes of colour on the hillside. A dark red-brown lower down give a richness to the middle-distance.

18. Add some dark and mid-grey to the path so that it's not the same colour and tone all over, then blend a little with a finger or a shaper.

19. Continue to add in further touches of colour: here pinky browns and greens have been added to the moorland, and soft green has been added to the path. To create very fine grasses in the bottom right-hand corner, lightly touch or tap the body of light green and ochre pastels on to the paper to create grasses at different angles. Use a side of your pastel that has been worn to an edge to create the grasses – the tip would give far less precision.

20. Create a dry-stone wall along the top of the hill with the tip of the black pastel, as shown, leaving a few light areas here and there.

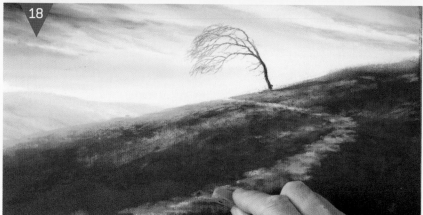

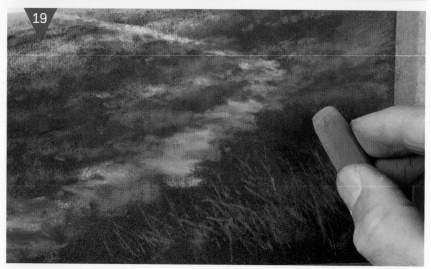

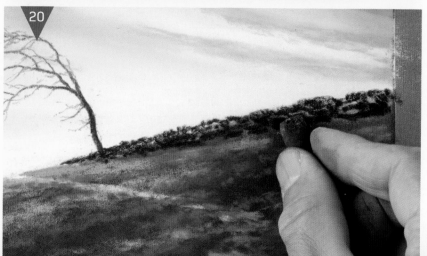

21. Soften small areas of the wall with the shaper.

22. At regular intervals along the top of the wall, draw in posts using the brown pastel pencil. Use the black pastel pencil to add any final detail in the wall or the tree.

23. With the body of the pastel, add little bits of black gently to the foreground, to give a really moody atmosphere.

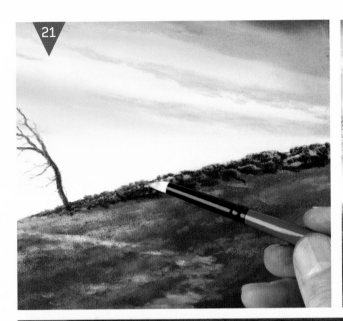

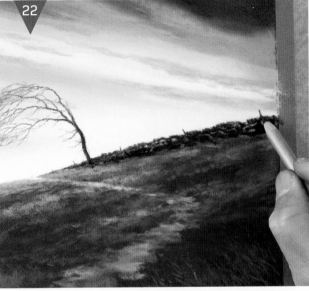

51

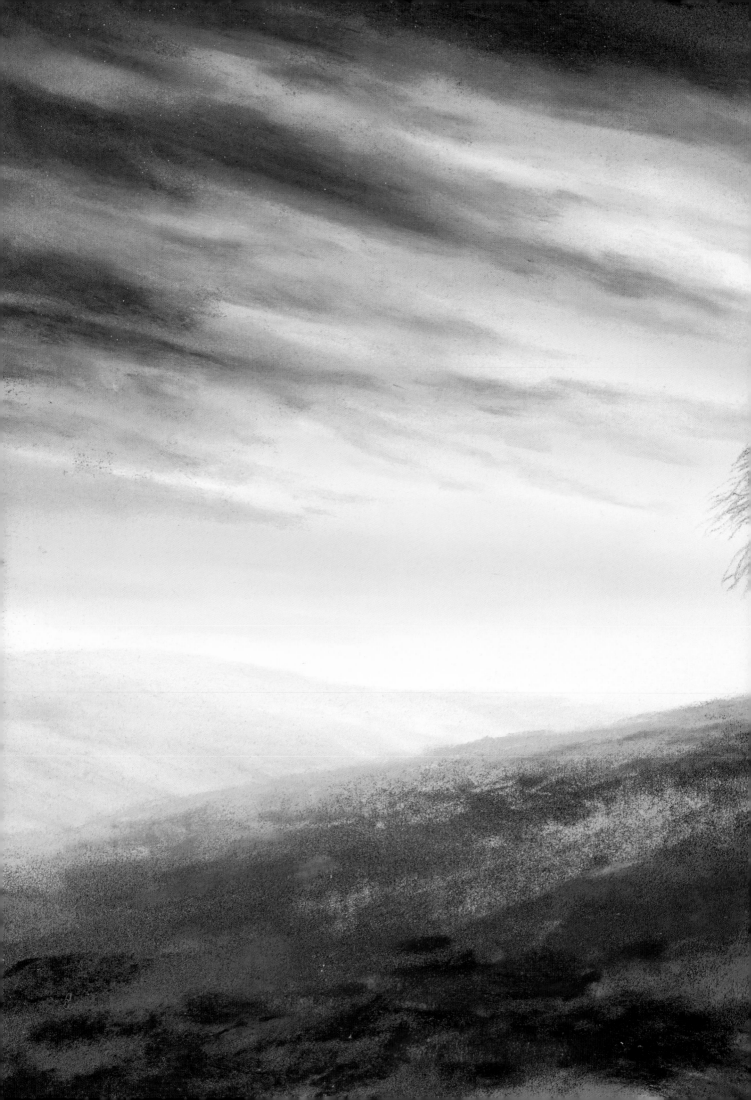

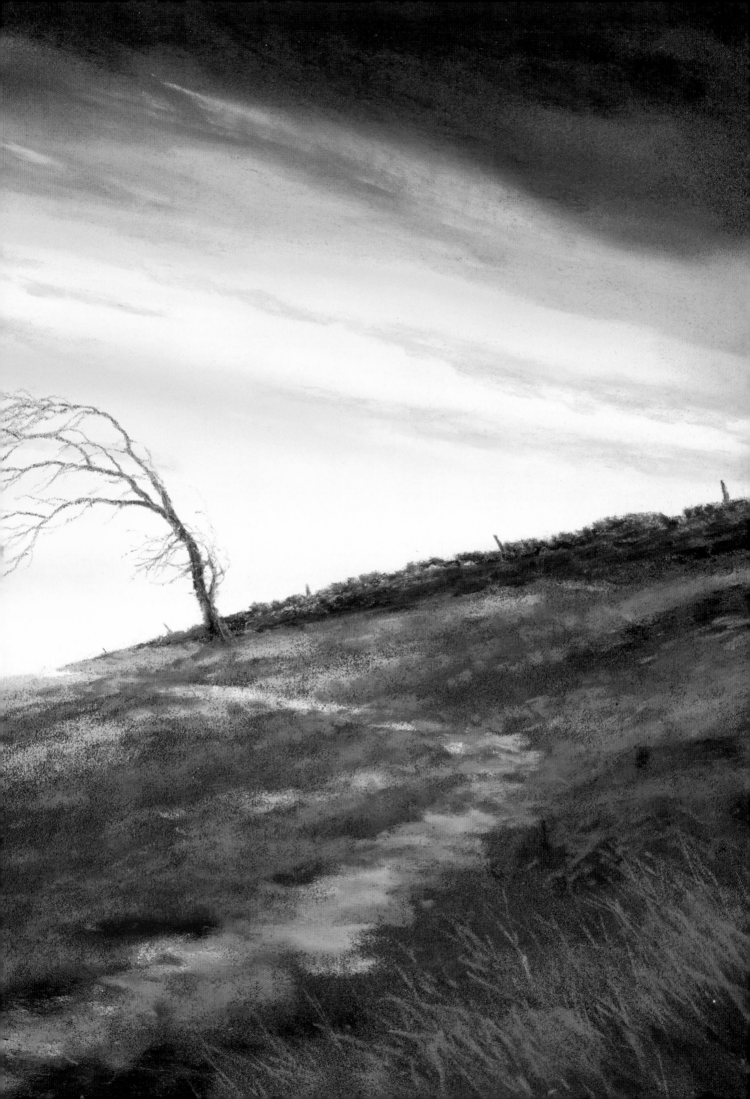

Skyscapes

Often the sky creates the atmosphere in a painting, and as there are many different skies, so there are many different ways of painting them. A few good techniques to have up your sleeve are some basic cloud-shaping skills and the knowledge of how to create a basic sunrise or sunset.

Clouds

If there are not many clouds in a sky then a good way to start is to paint the overall background colour or colours then put the clouds on top.

Soft clouds

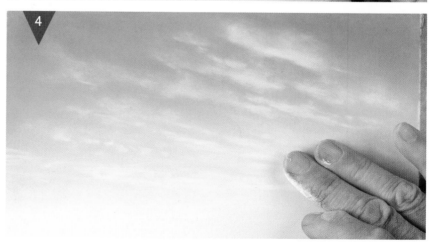

1. Cover the upper part of the sky using the side of a blue pastel and cover the lower part of the sky either with a paler blue or white. Blend the two colours smoothly with your fingers to create a deeper blue at the top that blends softly to a paler blue lower down.

2. Use the side of a white pastel lightly to touch the paper in the direction you want the clouds to go. If the pastel has worn down to a flat side, use this as it will help to create a more irregular shape.

3. For thinner, more streaky clouds, use the tip of the pastel.

4. If you want to soften, gently touch your finger over the clouds in the direction they're going. If you prefer more distinct clouds, don't soften at all.

Fluffy clouds

If the sky is covered with clouds it might be easier to create the sky around the clouds – this utilises the white of the paper for the white of the clouds.

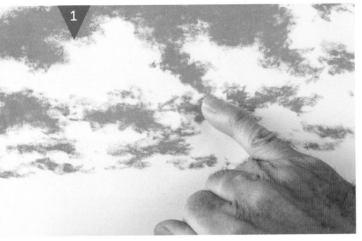

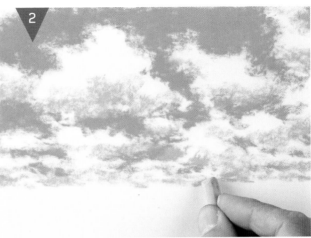

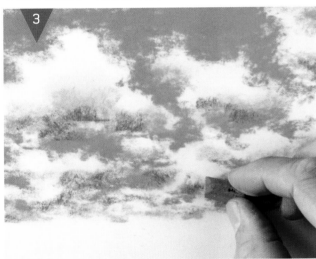

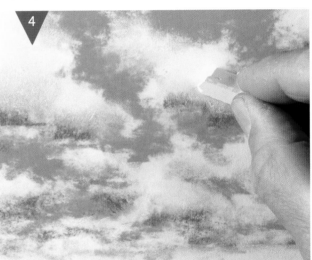

1. Drag the side of a blue pastel over the sky area, creating cloud shapes wherever you don't apply the pastel. If you don't press very hard you'll create a nice rough edge to the clouds that helps them look natural. If you want to soften the edges of the clouds, rub in with your finger or a shaper.

2. Add some pale grey to the bottom of the clouds, using the side of the pastel for large areas and the tip for smaller clouds.

3. Add a dark grey underneath the clouds in the same way.

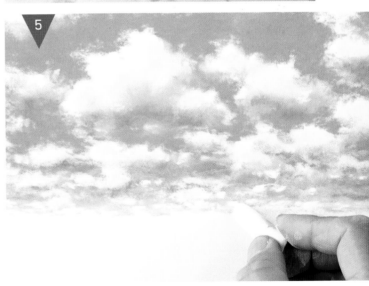

4. Apply pale cream to the middle of the clouds then soften all the colours together with a finger, blending gently.

5. If you need any more clouds or wish to reshape any, use the white and soften if necessary. Remember not to make the clouds too neat, particularly around the edges. A paler blue was added lower down the sky to suggest distance.

Cloud gallery

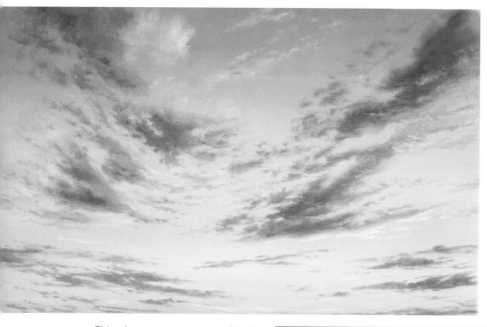

In this sunset skyscene, I put the blue and yellow sky colours in first, starting at the top and working down towards the horizon. After softening this with my fingers I added the clouds. The colour difference in the clouds captures the dramatic light at this time of day; don't be afraid to use dark and light colours to show off this contrast. Apply the wispy dark streaks first by gently stroking the paper with your pastel. When you are happy with the arrangement, add the lighter highlights on top. Carefully soften the larger clouds with your finger and the smaller clouds with a shaper.

This skyscene was created in the same way as the example above, with the grey-blue and yellow sky created first. When I created the clouds I was careful not to rub or soften them all too much, as I wanted the contrast of the smoother clouds towards the bottom of the piece in the distance, and rougher, fluffier clouds in the upper foreground. Also, note the changing angle of the clouds, which creates a sense of perspective.

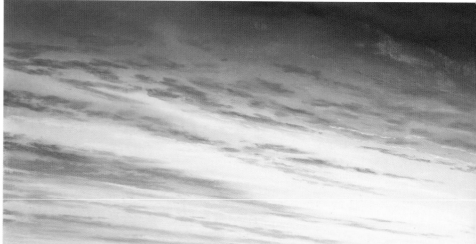

These stormy clouds were applied gradually on top of a pale sky – I was careful not to put too much initial pastel down for the sky, otherwise the dark colours on top would not take well. The strong dark greys and black are heaviest in the top left-hand corner, and lighten gradually across the sky, creating the drama of the scene. Soften the clouds evenly a little with a finger.

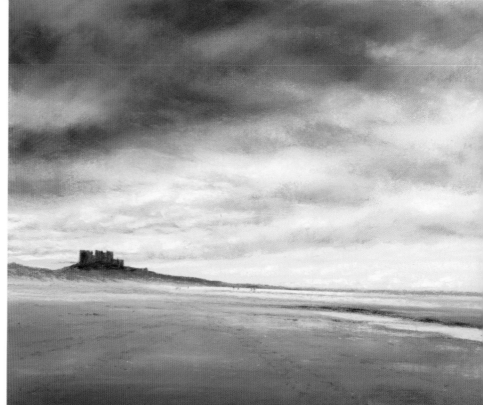

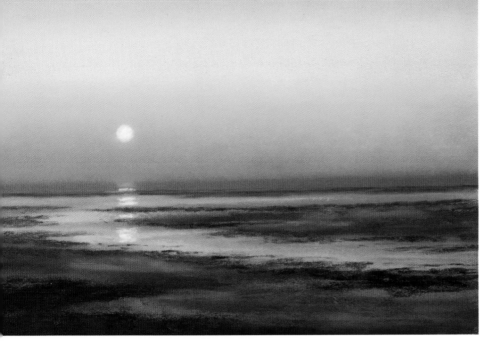

Sunsets and sunrises

There is no discernible difference between the colours of a sunrise and the colours of a sunset. The light and colours can be intense and dramatic or subtle and delicate. Try this exercise to practise creating a dazzling, golden horizon line and watery reflections.

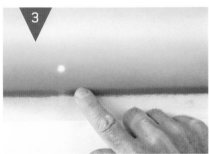

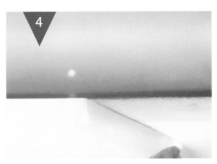

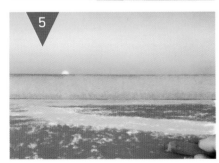

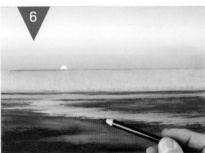

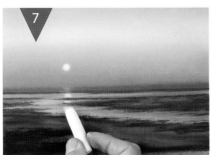

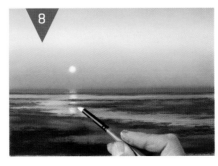

1. Firstly, put a strip of masking tape across the horizon to ensure a straight line – here it sits about halfway up the page. Use the side or body of a mid-blue pastel at the top then lightly apply a pale cream colour in the same way underneath, then deeper oranges and reds underneath that. Blend the colours together so they 'melt' into one another, smoothing the colours up to the tape.

2. Use the tip of a white to create the sun, softening the edge slightly with a finger or shaper. If the white doesn't cover the sky colour very well, put a small drop of isopropyl alcohol over the sun's area, let it dry then apply the white.

3. Apply soft grey along the horizon, using the tip, leaving a gap directly underneath the sun. Soften gently with a finger.

4. Remove the masking tape.

5. Move the strip of masking tape up so that it covers the bottom of the sky. Only press the lower edge of the tape down. Apply oranges and browns to the foreground, adding touches of pale grey here and there.

6. Soften delicate areas with a shaper. Continue to build up the land with dark grey or black; use a pastel pencil to create precision at the water's edge.

7. Remove the masking tape. Add reflections of the sun with white, with some pale yellow around the edges.

8. Soften gently with a clean shaper.

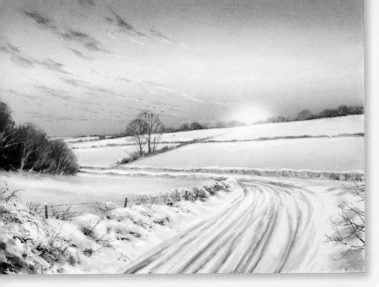

Snowy Lane

The dazzling, icy white of the snow complements the warm explosion of colour from the setting sun. Fine detail is used selectively here, in the foreground hedgerow and the trees, with areas of the sky and fields left smoothly blended for contrast.

Colours needed

Pale blue, mid-blue, white, pale blue, cream, pale pink-orange, orange, orange-brown, yellow, mid-grey, orange, pale blue, pale grey and dark brown pastels plus white, dark brown and black pastel pencils.

1. Using the tip of a pale blue pastel, draw in the structure of the picture: position the sloping horizon, the trees on the left and the sweeping tracks in the road.

2. Use the side of the mid-blue to apply the top edge of the sky, then overlay the lower part of the blue with white. Soften the two colours together.

3. Continue to build up layers of colour: apply a layer of cream colour, using the side of the pastel.

4. Under the band of cream, apply a strip of pale pink-orange, then orange in the same way. Leave a gap towards the right-hand side where the sun will be.

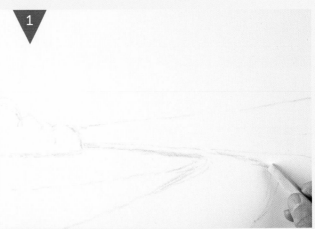

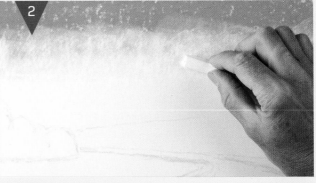

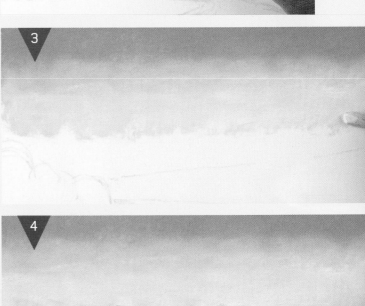

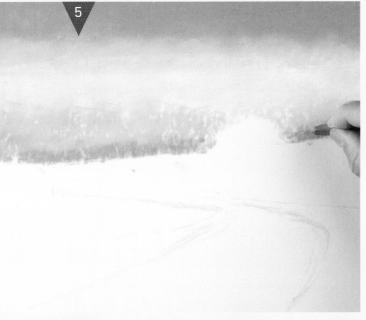

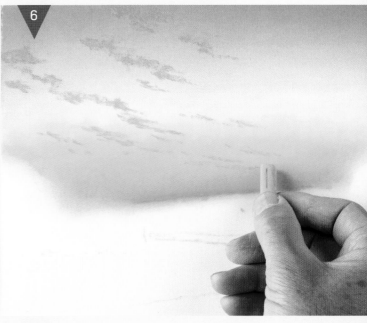

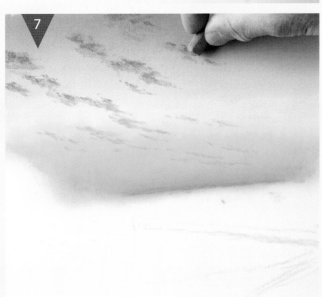

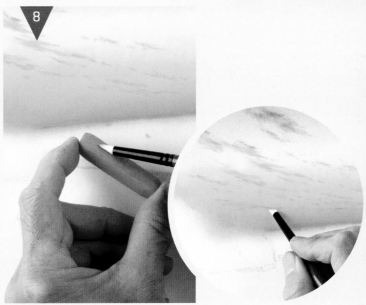

5. To add more depth to the sky, apply a few delicate touches of yellow on top of the pink and orange areas, then add a final delicate band of orange along the horizon line. Carefully blend all the colours together with your fingers.

7. Add touches of grey to the upper part of the clouds to create shadows. Very gently, soften slightly with a finger in the direction the clouds are going. A shaper can also be used to soften the edges of clouds a little.

6. Use the tip of the orange or orange-brown to create little wisps of clouds, using very little pressure. They should be largest towards the top, and decrease in size further down.

8. For very fine clouds you can use the shaper to lift some colour off the pastel stick then apply it to small areas for distant clouds. Add in some touches of orange and then white to the lower clouds, cleaning the shaper thoroughly between uses. A little white may be needed to lighten the edge of the sun's area. Soften afterwards with a clean finger.

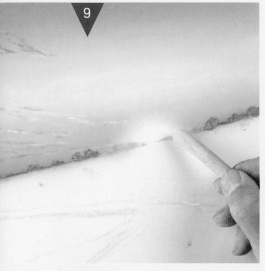

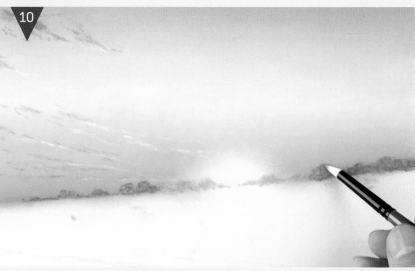

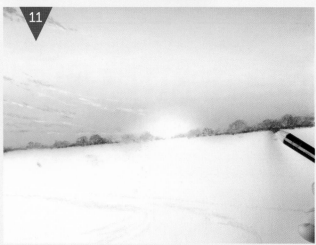

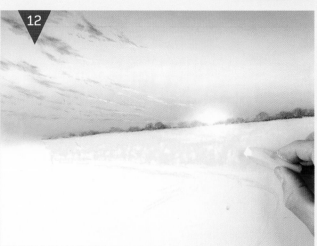

9. Add in tree-like shapes along the horizon line. Use the tip of a yellow pastel to create trees in front of the sunny area; use the tip of an orange pastel and an orange-brown to create trees elsewhere.

10. Soften the tree shapes slightly either with a finger or shaper.

11. Add a little dark brown or dark grey pastel pencil to sharpen the bottom of the tree-line, where it meets the snow.

12. Cover the field under the trees with a pale blue, using the side of the pastel. Add white to the snow directly underneath the sun, and cover the pale blue with a fine layer of white.

13. Apply a layer of pale grey – about the width of the pastel – to the bottom of the field. Soften the colours together.

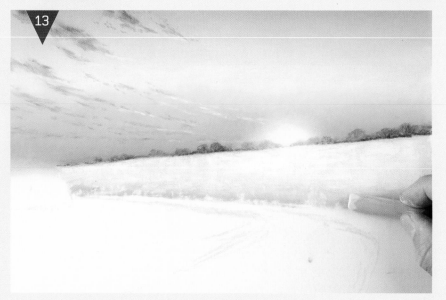

14 Use the tip of a white pastel to create a distant field on the left, of the picture, then soften with the shaper.

16. Using a sharp pastel pencil, create the trees growing out of the hedge. Draw in the main structure first, then add the finer branches. To create the trees to the left of the picture, drag the side of a dark brown pastel downwards (or upwards). Continue to add touches of other browns and oranges.

15. Use a brown pastel pencil lightly to create uneven hedges, keeping the bottom of each hedge flat, and dividing the field into four. Apply black pastel pencil in places, to create a richer tone. Add in a vertical line to indicate the position of the trees.

17. Soften the browns and oranges together with a finger. Use the tip of the white pastel to create a loose framework of snow-covered branches.

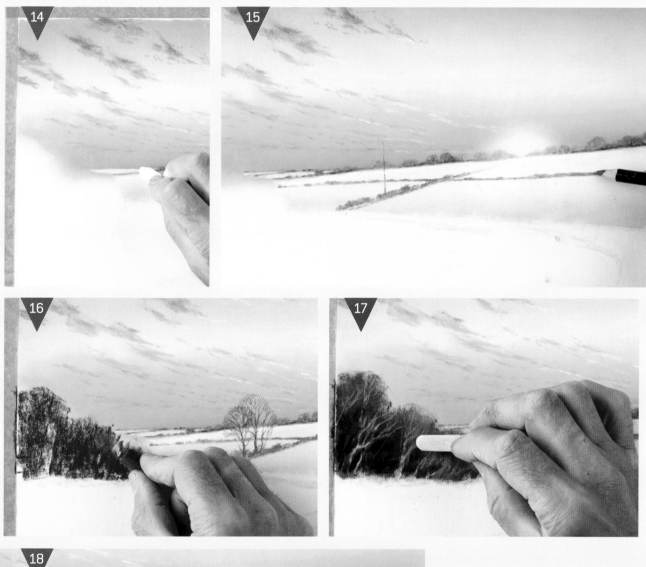

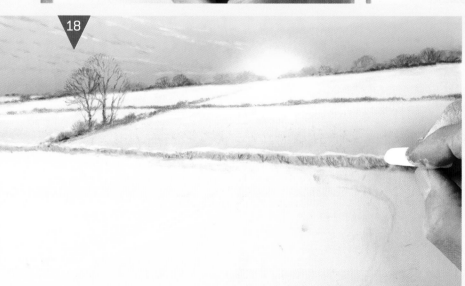

18. Use a pastel pencil lightly again to create another hedge that runs along the bottom of the field and across to the right-hand edge. Underline the hedge with pale blue pastel. Use the tip of a white pastel to add a layer of snow on top of the hedge.

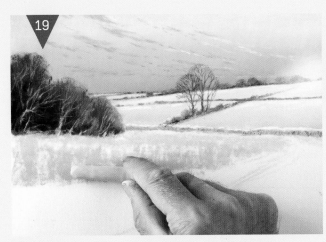

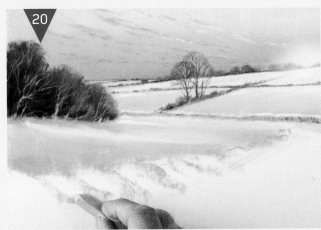

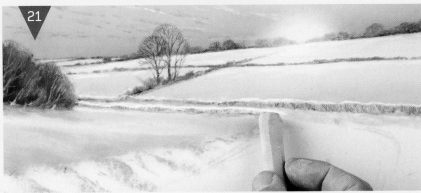

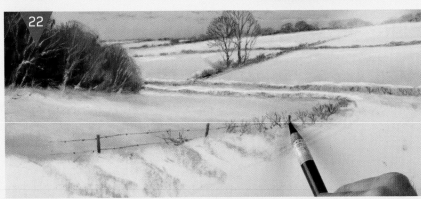

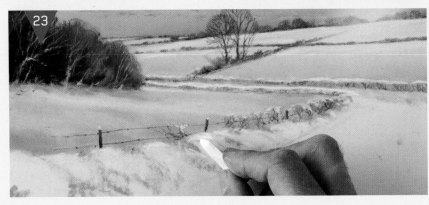

19. Using the sides of the pastels, overlay light bands of pale blue and pale grey in the lower field, varying the tones slightly, and leaving some areas white. Soften the colours together, blending in a horizontal direction. Add a few more streaks of white on top afterwards, if necessary.

20. Use a mid-blue to create shadows on the banks of snow in the near hedge. Work the colour at a slight angle, applying it lightly and leaving large areas of paper white.

21. Create another hedge on the near side of the road, stopping when you reach the bend. Underline the hedge with pale blue shadow. You may need to add a little white on top of the hedge, if it doesn't stand out clearly enough.

22. Now create the hedge as it sweeps round into the foreground. Use a pastel pencil to draw in the fine branches, and to add in some posts and wire.

23. Highlight sunlit snow on the top of the bank and add little bits of snow to the hedge using the tip of a white pastel.

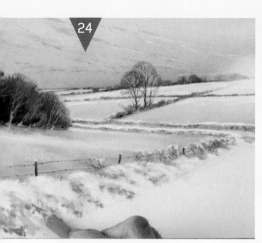

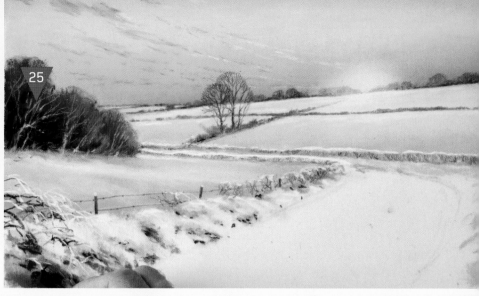

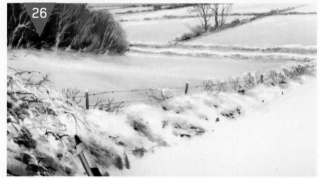

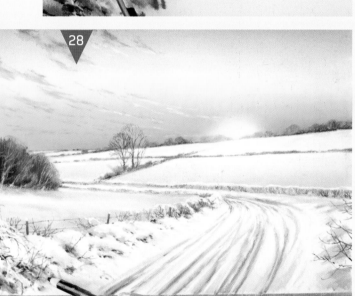

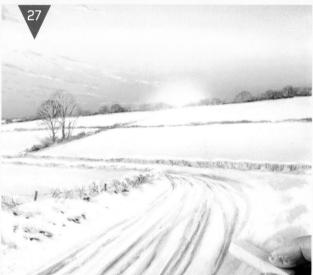

24. Use the side or the tip of a mid-grey pastel to create deeper shadows in the snow bank.

25. Use white and dark brown pastel pencils to create a twiggy shrub to the left-hand side of the foreground. Continue to deepen the shadows along the snow bank using dark brown and black to give a sense of depth. Soften here and there with a shaper where required.

26. Use a black pastel pencil to add fine details such as grasses and twigs in the foreground and along the snow bank.

27. Following the sweep of the road, add lines of pale blue, pale grey, and white to suggest tracks in the road. Soften with your fingers and then add more pastel if necessary. Also add in some touches of mid-blue, white and pale grey to the right-hand snow bank.

28. Add more grasses or twigs, if necessary, to the left-hand side using the pastel pencil. Also add in some twigs creeping in from the right-hand side.

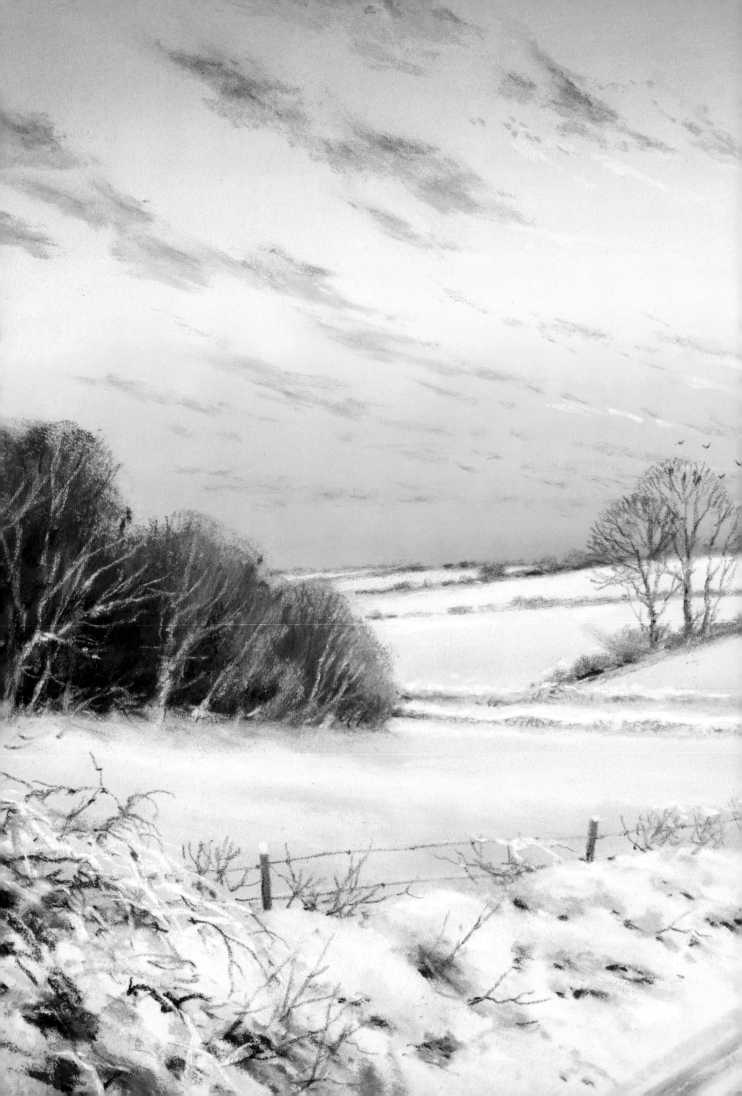

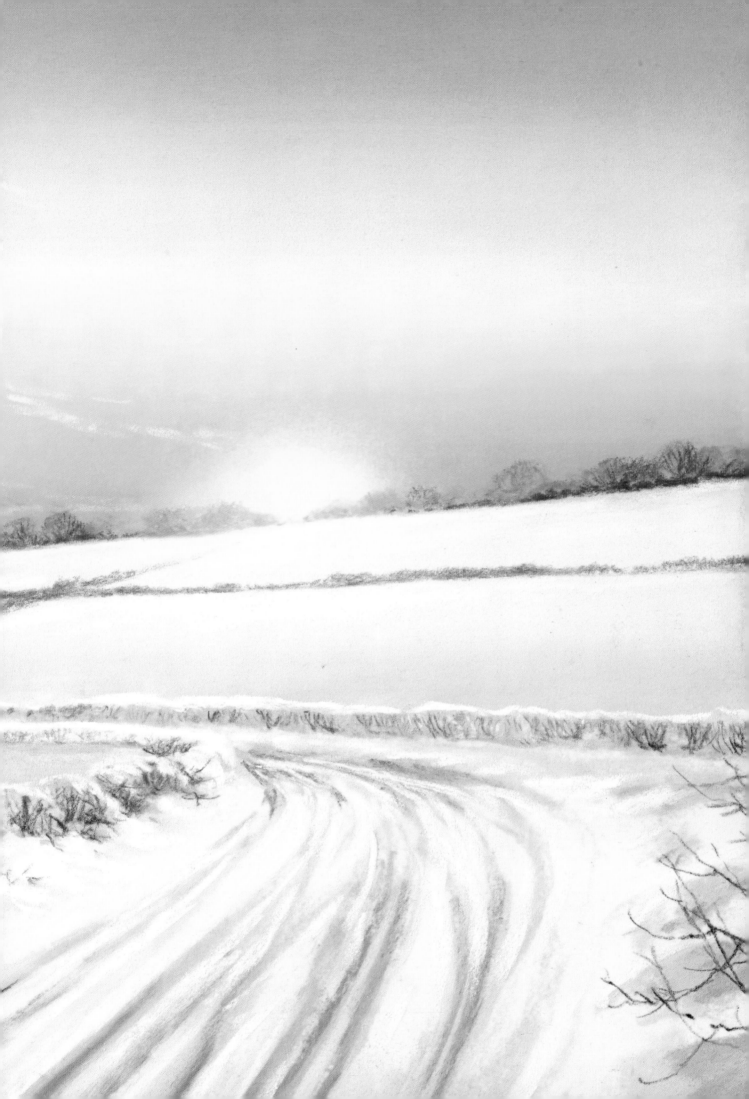

Elements of the landscape

In order to bring a landscape to life it is important to be confident with key elements such as water and trees. Always keep good references such as photographs or sketches to hand, because creating them from your imagination is rarely convincing. There is no 'trick' for doing any of these, just lots of practise and hard observation!

Water

Water can be rough, smooth, rippled, reflective, deep, calm, moving or even several of these things all at the same time, so trying to capture it can be a little challenging. If I'm uncertain about how to create it, I'll try it on spare pastel paper first. There is no substitute for practice!

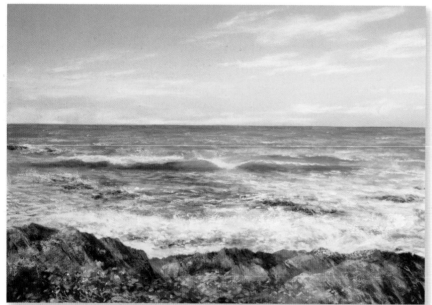

Masking tape was used to get a straight line on the horizon. The movement of the sea was achieved by small strokes of pastel and subtle changes of tone and colour. The movement of the waves is brought to life by flaking some white pastel over the sea surface and on to the foreground rocks to create sea spray (see page 20). I also had a very good, clear photograph to work from.

In this scene, the sea has washed in, leaving the sky reflecting in the wet sand. To capture this effectively I gently stroked the colour used for the sky across the foreground and middle distance, and only slightly softened it. The effect is completed by creating reflections of the trio of people walking on the beach.

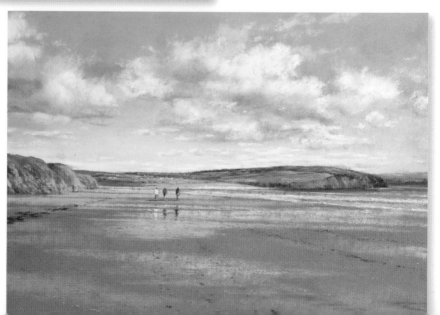

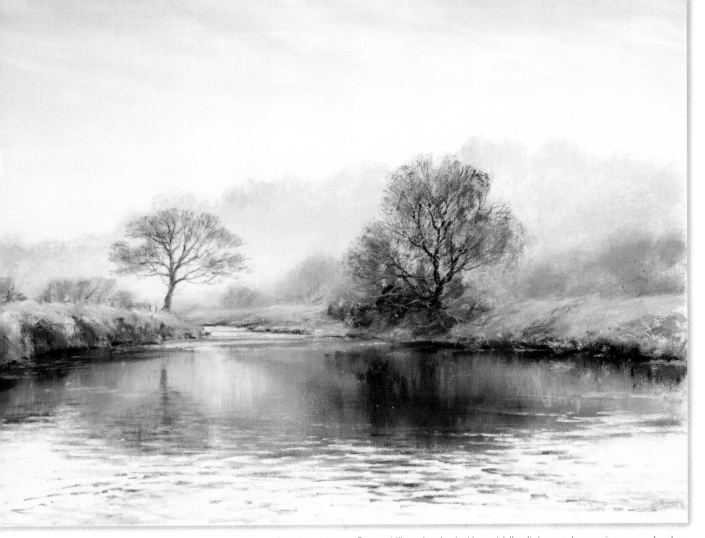

Here, the river moves from still and calm in the middle distance, becoming more broken and rippled as it flows into the foreground. The key to creating this effect is to be selective with the colour and smoothness of your pastel: in the middle distance there is a rich mirror of colour, softly blended; in the foreground the surface becomes broken with short, rough strokes of pastel in only a select few colours, and with areas of the paper left showing through.

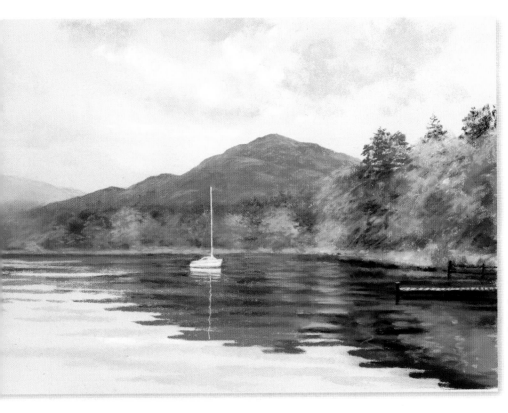

The water in the lake is generally calm with just the faintest distortion of reflections suggesting gentle movement. To create this effect, use the same colours as for the trees and hills, but use short, horizontal strokes and smooth them together.

67

How to create a reflection

Reflections are just mirror images that may be distorted by movement in water. How much reflection there will be depends on one's eye-level and the stillness or turbulence of the water. This piece contains areas of both smooth and rippled water, so that you can practise creating both.

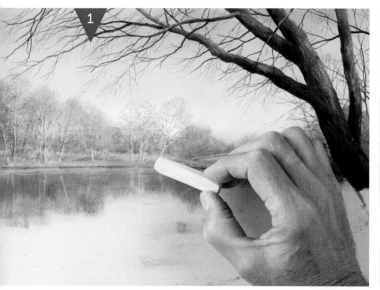

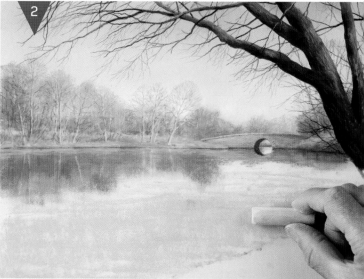

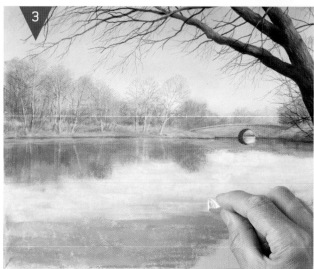

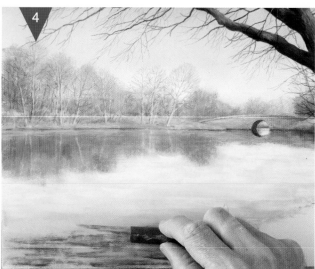

1. The far bank of trees was created first. Using the same colours, block in a mirror image of the colours below the waterline, but with less detail. Blend and soften these much more than the actual bank and trees above. Add in reflections of a few large structural details, such as the trunks of the trees.

3. The sky colours are reflecting in the water, creating a deeper blue towards the bottom of the picture. As in step 2, use the side of the pastel to block in darker horizontal strokes. If the contrast is too great, overlay the join with white, then soften all the colours together using your fingers.

2. The middle distance and foreground water has more movement than the distant water: use the side of a blue pastel to block in the rest of the water. Do not entirely cover the paper, and keep the strokes horizontal.

4. Continue to deepen the colour at the water's edge. Add a darker blue, used and then blended horizontally, to give an impression of subtle movement.

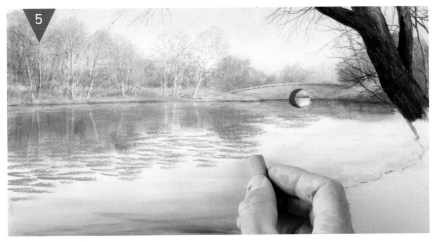

5. Create the transition between the still, far water and the rippled foreground water. Add in some short broken, horizontal strokes; I chose a soft purple-brown here, as it matches the reflection of my distant trees.

6. Use the shaper to push these pastel marks into the paper – a finger might possibly smudge too much.

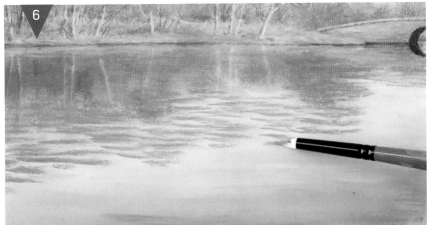

7. Continue to work on this transition area: add little white ripples with the tip of the pastel to create the illusion of the sun bouncing on the water.

8. Add in any further reflected details, being careful not to overdo it. Here I used the tip of a yellow-green pastel to create the reflection of a tree trunk. Lower down the reflection I used a black pastel pencil for more control.

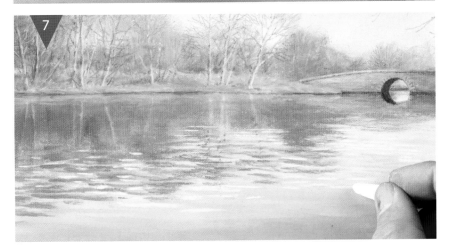

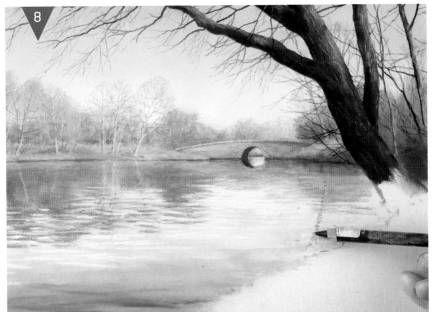

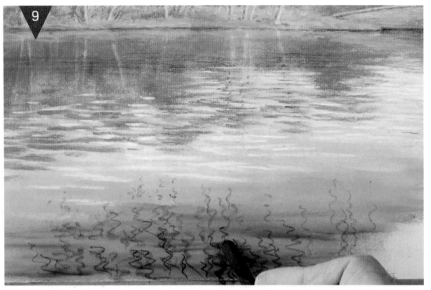

9. Create the reflections of the overhanging twigs: use a black pastel pencil for fine lines and a black pastel stick for larger reflections. Note how they zigzag due to the movement.

10. Add in some darker ripples along the edge of the foreground bank, to reflect the nearer, darker trees.

11. With your reflections complete you can now finish off the picture. The dark bank in the foreground completes the painting and increases the brightness of the water, due to the strong contrasting tones.

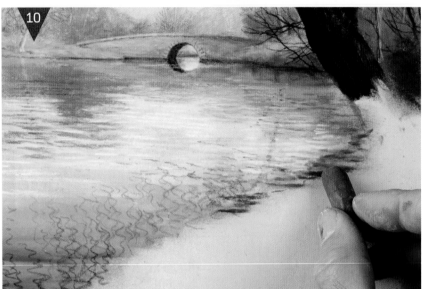

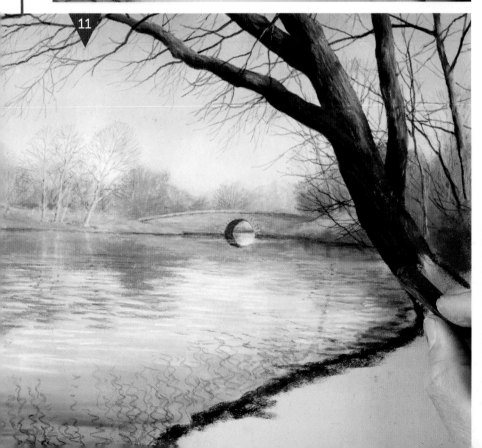

Tip: start over
If a picture is going wrong, paint over the troublesome area with isopropyl alcohol and start again. If it's all going wrong, paint the alcohol over all of it!

Waterfalls

The direction of the fall of the water can be shown by the direction with which you use the pastel. Start carefully and lightly, then gradually increase the pressure, tone and colour.

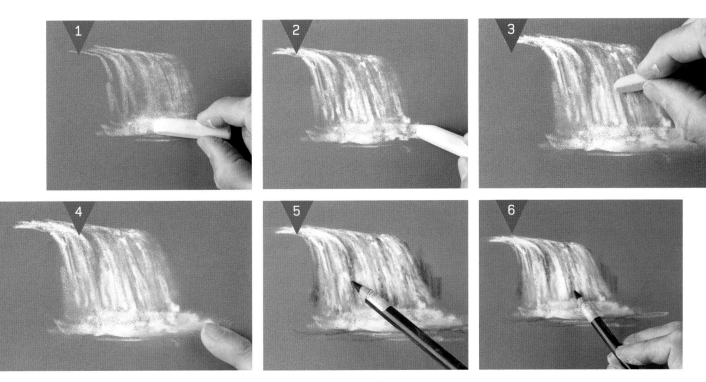

1. Begin by sketching in the rough overall shape. Note the curved direction in which the white pastel has been applied. Use the tip gently to create the vertical lines and at the bottom of the waterfall use the body of the pastel horizontally for the splash.

2. Continue to build up the layers of pastel: increase the pressure a little, giving more strength to the white here and there.

3. With the tip of the pastel, add in some pale blue and mid-blue streaks amongst the white, and add some blue aound the splash at the bottom.

4. Soften a little with a finger or shaper.

5. Add in some darks using a black pastel pencil to achieve depth.

6. Stand back and assess the effect then add any final touches. When the waterfall has the surrounding colours and dark contrasting tones it stands out nicely.

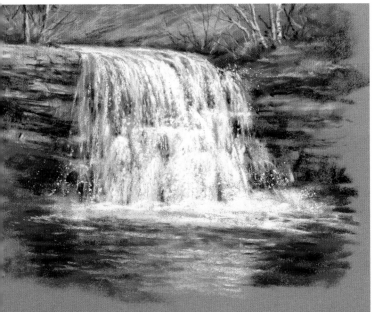

When setting a waterfall in context, add in choppy reflections around the bottom to indicate the force of the falling water, and add some flakes of white to create the illusion of spray (see page 20).

Trees

We all know what trees look like, until we come to draw them! There are many different kinds of trees whose shape and structure vary so much that I can't cover them all in one small section here. Again, reference is important so have a look at the shapes they make, with leaves and without.

Simple winter trees

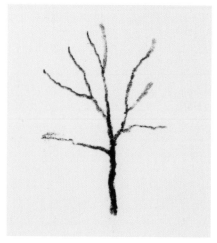

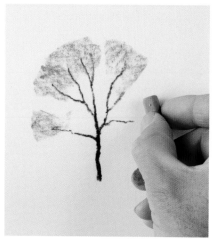

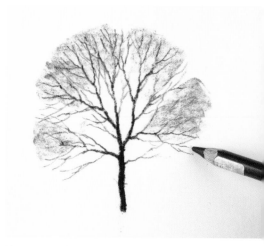

Draw a wobbly tree trunk, making it wider at the bottom and thinning towards the top. Use the tip of a black, dark brown or dark grey pastel for this, adding side branches at different heights. Start at the top if you find it easier than starting at the base.

Use the side of a mid-grey or mid-brown pastel to drag lightly from beyond the tips of the drawn branches in towards the tree, possibly leaving a few gaps between branches – a short or broken pastel is easier for this than a long one.

Use a pastel pencil to add in some fine detail, creating little twigs and branches here and there.

Soft and smudgy winter trees

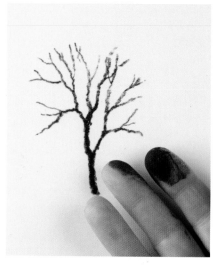

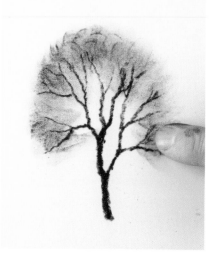

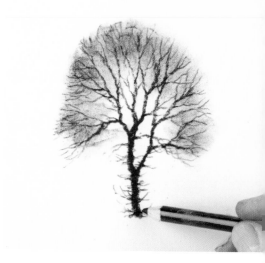

Draw a tree trunk as in step 1 above, this time with smaller branches coming from the trunk at different heights. Notice how dirty your fingers are!

Use a dirty finger to touch the pastel on to the fine-twig area, around the edge of the tree. Smudge it slightly inwards, creating the soft effect of the twigs.

Add twigs and fine branches with a black pastel pencil here and there.

Simple summer trees

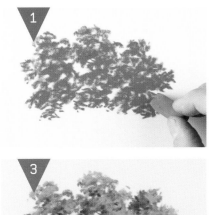
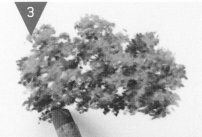
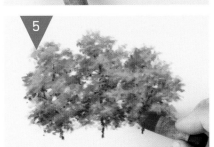

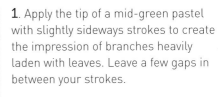

1. Apply the tip of a mid-green pastel with slightly sideways strokes to create the impression of branches heavily laden with leaves. Leave a few gaps in between your strokes.

2. Go over some of the mid-green with a lighter green in the same way.

3. In between the light and mid-green, add little touches of a dark green to give the depth of leaves in shadow.

4. If required, soften all the leaves a little with the pastel shaper.

5. Use a very dark green – or even a little careful black – to create darker shadows and tree trunks.

6. Highlight some light clusters of leaves here and there with a yellow. Notice how the light leaves come forward and the dark leaves recede.

Trees gallery

As the examples below show, there is no one correct way to create a tree. In the example on the left, a few autumnal leaves cling to the skeletal branches of some autumn trees. The lower bushes have lost their leaves and are a mass of fine, brown branches and twigs. In the example on the right, the trees are much more loosely drawn, and vary in colour and tone. Notice how the direction of the strokes creates the direction of the branches covered with leaves. No actual branches are visible, only the leaves.

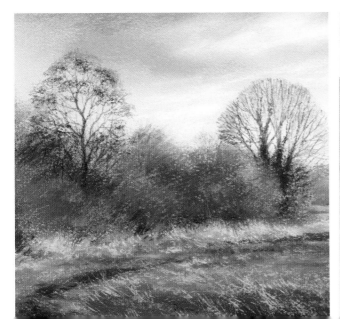
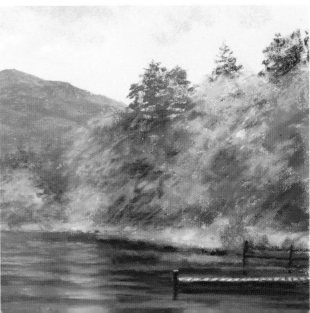

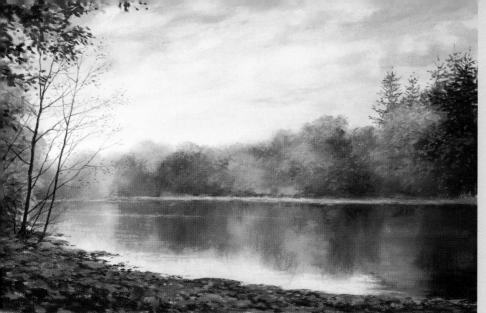

Reflections

I chose rich autumn tones for this colourful piece, but if you want to, choose your own colours and see what results you get by overlaying them.

1

Colours needed

Pale grey, white, cream, mid-blue, pale blue, pale purple, a selection of greens and browns, orange, yellow, mid-grey, dark grey and black pastels plus black and brown pastel pencils.

1. Using the tip of a pale grey pastel roughly sketch in your composition: draw a line for the water's edge about a third of the way up. Draw a sketchy line roughly indicating the height of your trees above this line. Draw the foreground river edge, tapering towards the bottom right-hand corner, and finally add in some trees on the left-hand side.

2. Use the body of the white pastel above the tree line, then add the cream above it. Aim to create a swooping, wispy, cloud-like shape. Soften the colours together with a finger.

3. With the body of a mid-blue pastel, gently apply sky colour among the cream clouds and up to the top of the paper. Note the slight angle of these strokes.

4. Using the ends of the pastels, add touches of pale blue and pale purple among the mid-blue for variation, then soften a little with a finger if necessary.

2

3

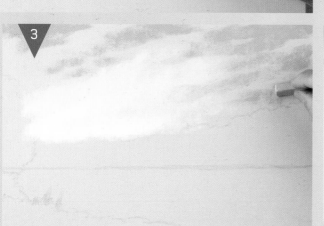

4

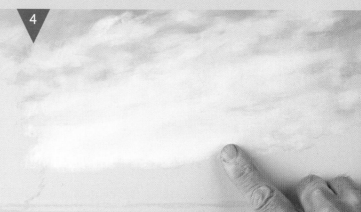

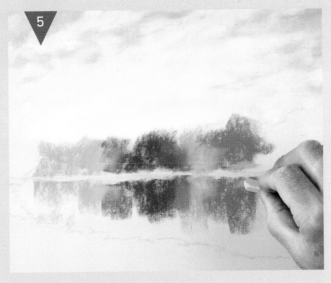

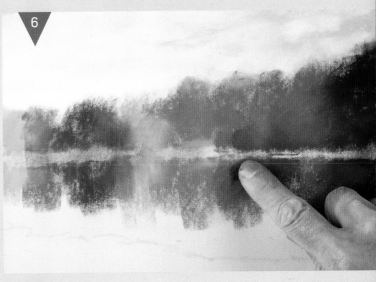

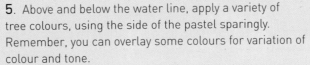

5. Above and below the water line, apply a variety of tree colours, using the side of the pastel sparingly. Remember, you can overlay some colours for variation of colour and tone.

6. Use a finger to melt some of these tree colours together a little, being careful not to smudge them too much.

7. If the trees look a little too uniform, vary the shapes and sizes by making some taller or broader.

8. Add subtle lights or darks within each tree for variation, using the tip of the pastel for precision.

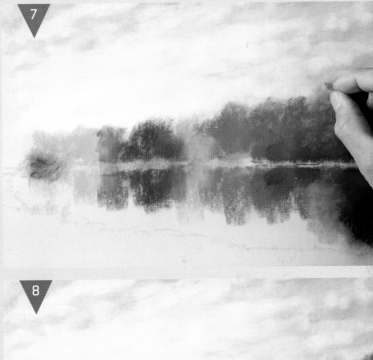

Tip: double up

Apply the colour for the reflections at the same time as you work on the trees – don't be tempted to put in all the trees and then all the reflections. This way you will have exactly the right colour for each tree's reflection.

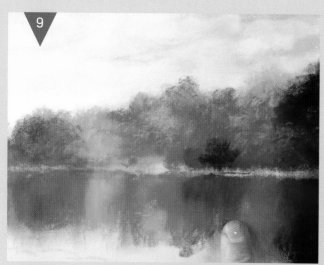

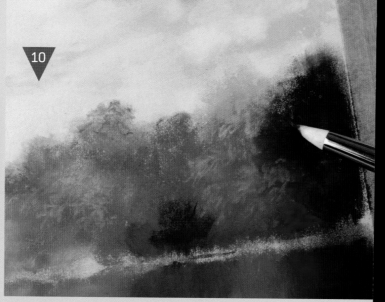

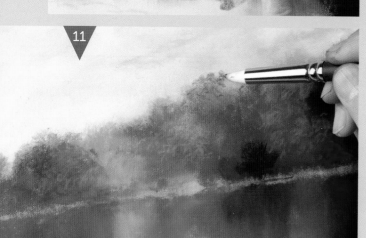

9. Each time you soften or blend, be careful not to smudge too much, and try not to overwork. The reflections can be softened more than the trees.

10. For some subtle and careful blending, use the pastel shaper. Blend small 'leaf-like' areas.

11. The pastel shaper can also be used to transfer colour from one area to another by touching it into one coloured area, then using the tip to place it elsewhere. Use this technique to add definition to some of the tree tops.

12 Identify the water's edge with a line of light brown.

13. Sharpen it up if necessary using the brown pastel pencil along the top edge.

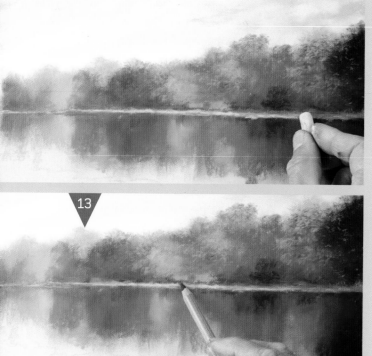

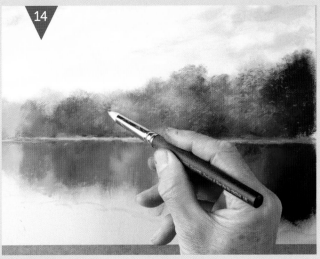

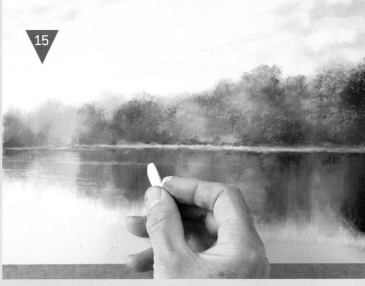

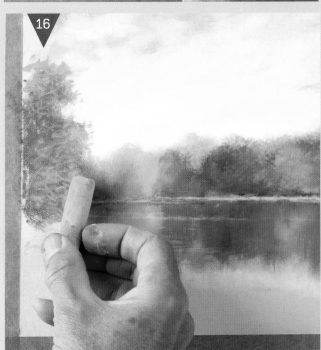

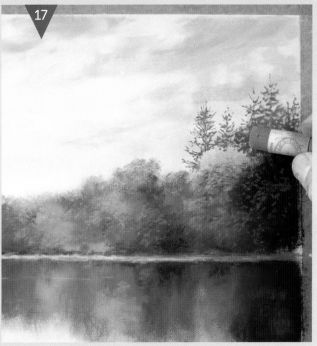

14. How much softening or blending to do is up to you. You can leave a lot to the imagination!

15. Use the tip of a white pastel to add a delicate white ripple, which breaks up the surface reflections nicely. However, be careful not to press too hard.

16. Use a mid-brown or orange as a base for the tree on the left, then go over this with the tip of a paler colour like yellow or cream, creating a slightly mottled effect with your pastel.

17. To balance the composition, add some conifers to the right-hand side. Use the tips of grey-greens and dark greens to sketch in the trunks, before adding further branches.

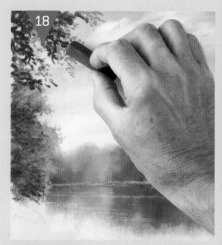

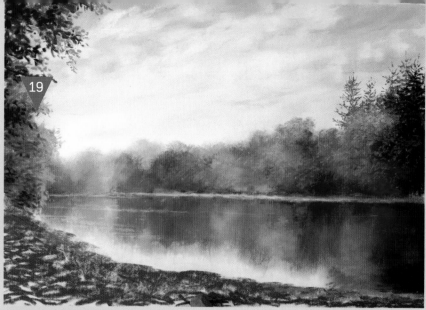

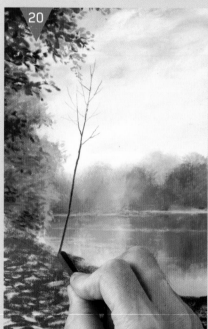

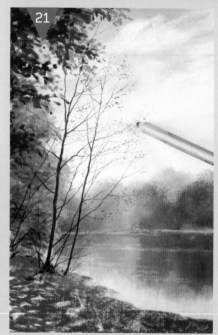

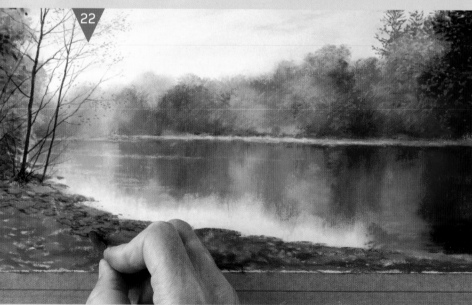

18. Using the tip of the orange, brown and yellow pastels, sketch in the overhanging branches at the top left, using small, delicate strokes. Add further detail to the tree below, creating small, leaf-like touches of colour, as before.

19. Use mid and dark greys to create your stony foreground; create small touches of colour using the tip of the pastel, not filling in the area completely – the light bits you leave will look like light on the stones.

20. Use either the sharp tip of a black pastel or the black pastel pencil to create stems of fine trees to the left-hand side. I find it easier to work downwards, but it doesn't matter which way you go as long as your trees are rooted in the ground! Add in a few further, finer branches using the black pencil.

21. Continue to build up the trees and add in further trunks and branches using the black pencil. Finish off the trees by adding some delicate, fine, brown leaves. These will need very little pressure – either use a brown pastel pencil or transfer some colour from a brown pastel with a shaper.

22. Continue to build up the foreground, adding other colours such as browns. Also add in a little black between some of the stones.

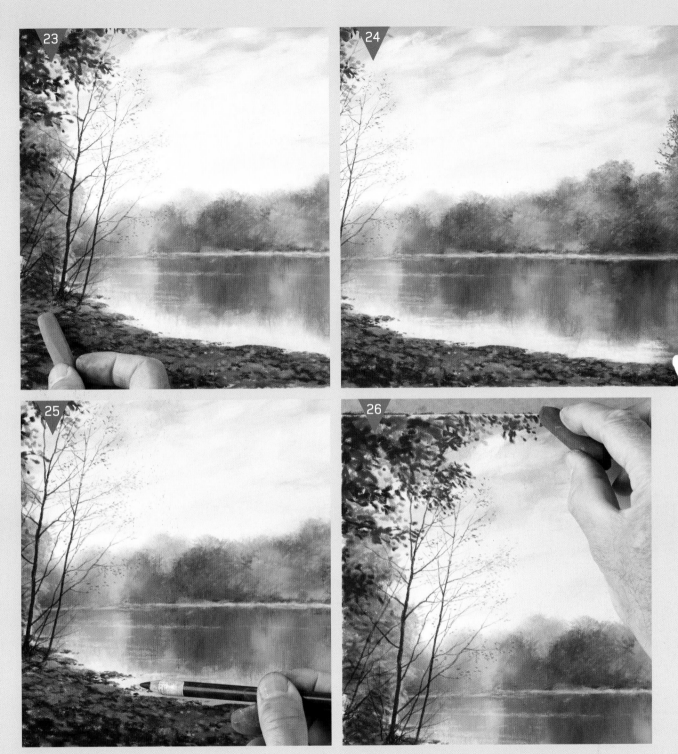

23. Continue to enrich the colours in the foreground – use some of the same colours from the trees above, to indicate that they have lost some of their leaves.

24. Draw in a few white ripples by the water's edge, keeping the strokes horizontal.

25. Use a black or dark brown pastel pencil to create odd rocks and stones by the water's edge. Use the pencil to define some of the shapes that are already present.

26. To finish off, extend and add more overhanging leaves to the top left-hand side using the tip of a dark brown pastel.

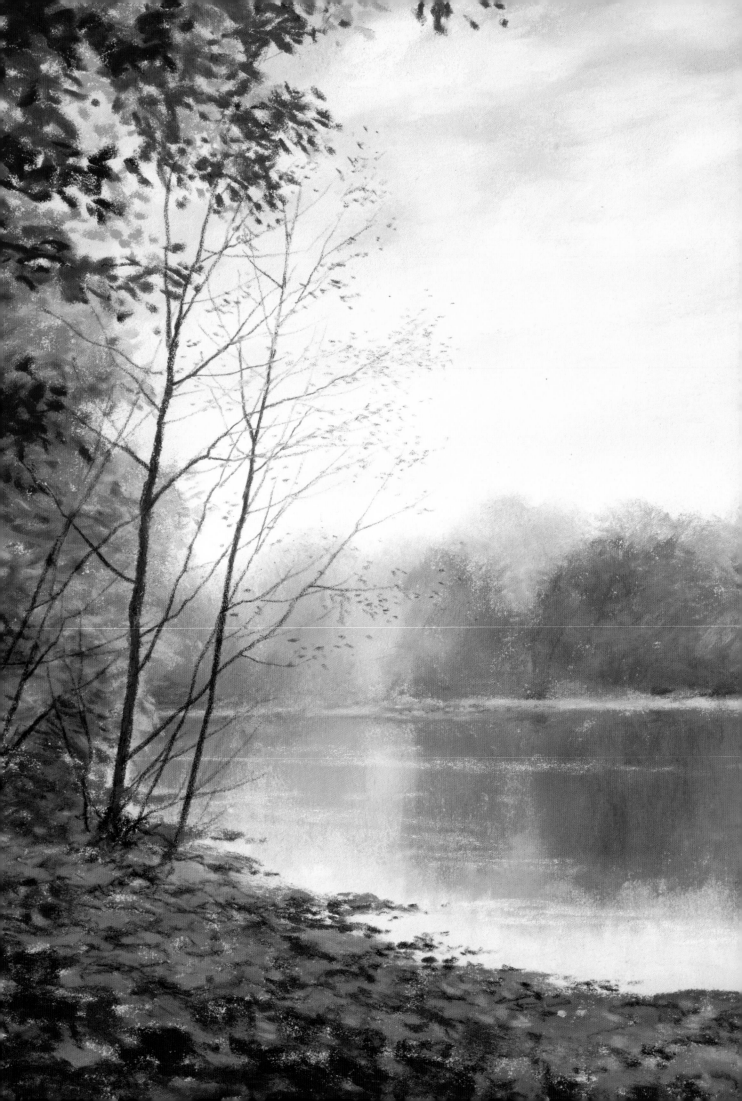

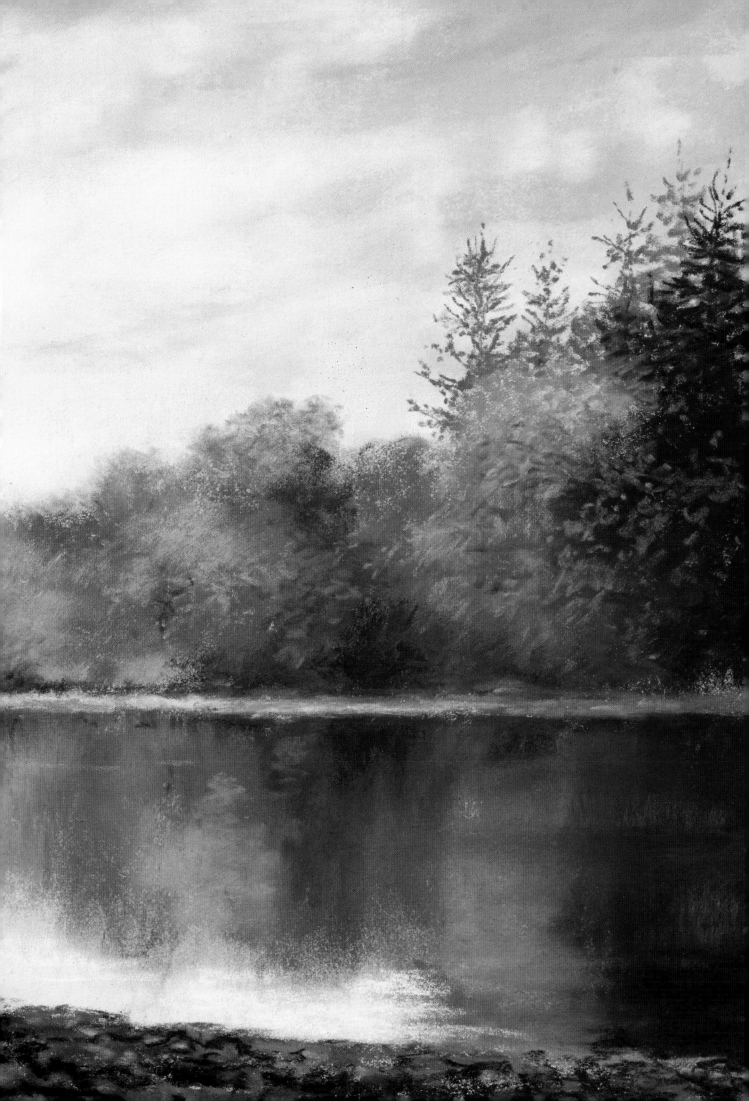

Composing from photographs

When working from a photograph or sketch, deciding which details should be left out and what should be included is fairly subjective. But if you're struggling to know where to start, ask yourself what it is about a picture that most interests you, How are you going to paint your picture without adding too much superfluous clutter? Don't feel that you have to copy a photograph in its entirety. You may find that all the information within the photograph is not necessary, so adapt it to suit your painting.

Adapting photographs

Sometimes the colours in a photograph can be too intense and there may not be enough variation between foreground and background colours and tones, so artistic license can be very helpful. Ask yourself: how much sky do I want? Would it be better with less or more foreground? Is there enough contrast? Do I need to put everything in? Just look at what you think is important about the photograph and think through how you want to show that. I often do thumbnail sketches and colour studies to decide this before working on a finished piece. Just changing a few details can make an enormous difference to the feel of a piece.

I felt that there was too much drama in the contrast of my photograph, so as you can see below in my finished piece, I lightened the sky and the scrubby beach grasses and added some warmth to the colour of the sand.

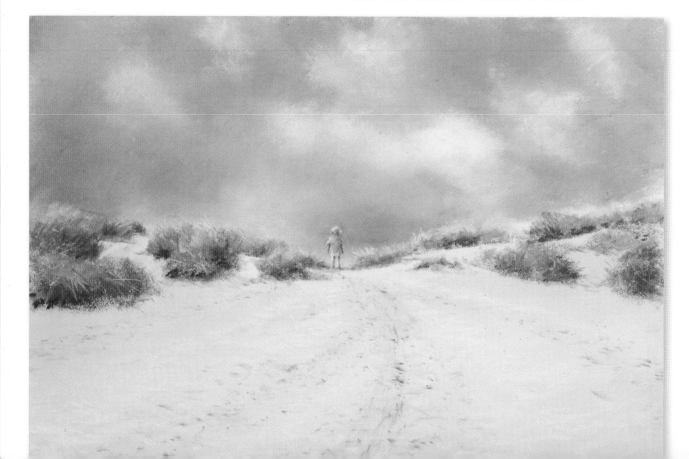

Deciding which details to keep

There isn't necessarily a right or wrong answer to this! I often paint the same picture with just subtle variations, and I will frequently change my mind as to which has worked best.

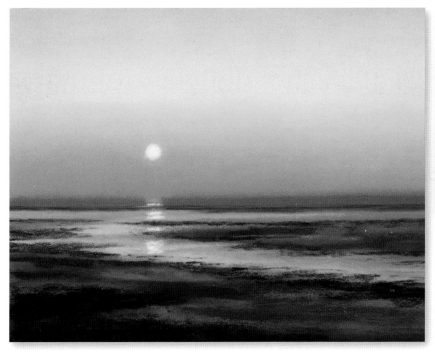

Here I raised the sun from the horizon and left out the streaky cloud. I used brighter colours and left the posts out. I've used more varied colours and tones in the foreground than were visible in the photograph, rather than just leaving a dark formless area (see page 57 for a demonstration of this painting).

Adapting paintings and sketches

I seldom work out of doors with pastels – I prefer to use pen or pencil sketches or watercolour studies as well as photographs.

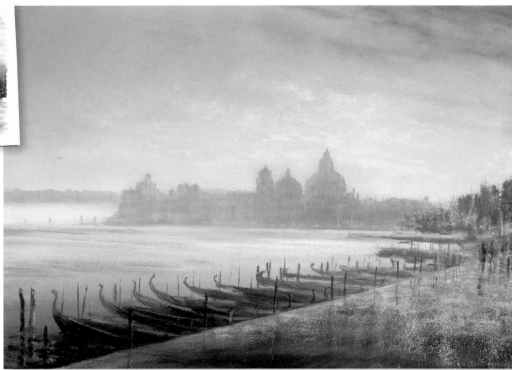

In my finished pastel piece I made the sky colours stonger than in my original watercolour painting, and I made the buildings a little more vague by softening them slightly. I liked this combination of colours, although other limited colour palettes could be as effective.

Creating depth

To create the illusion of depth, a great use of tones must be used. Further away, tones recede and the intensity of colours weakens. This is sometimes called aerial perspective.

Foreground detail

How much detail to put into a painting is a personal choice, and my own preference is to limit detail to certain areas, otherwise the eye does not know where to look. By including carefully placed elements on different scales you can convey a sense of distance: compare the size of the foreground flowers with the distant trees, which themselves recede from left to right across the painting.

Colour

Beware of using too much of the same colour everywhere. For example, if you are painting something which seems to be the same colour throughout, such as a road, use subtle variations of that colour to add interest. If a lawn looks the same green, vary it here and there with slightly paler and darker areas. If you look carefully in the middle of the field to the right you will see very slight variations of colour and tone here and there. I used these to create a direction or sweep, where a vehicle has turned, which leads the eye around the painting.

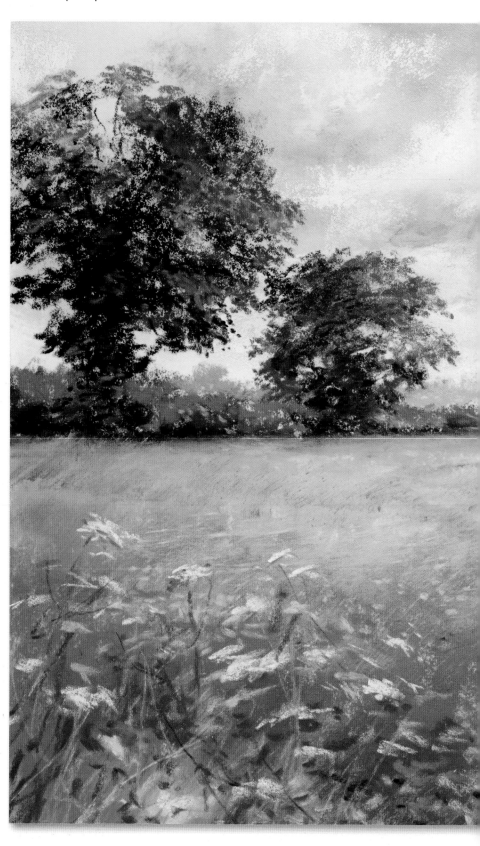

Softening the background

To get a feeling of hazy distance, I softened the clouds on the horizon and the far pale blue-grey trees. Try not to over-soften or rub too much or they might just disappear! Tap them gently with a finger or pastel shaper.

Tip: learn from your mistakes

Don't be afraid to make mistakes: they are how we learn what doesn't work and should be thought of positively as learning opportunities!

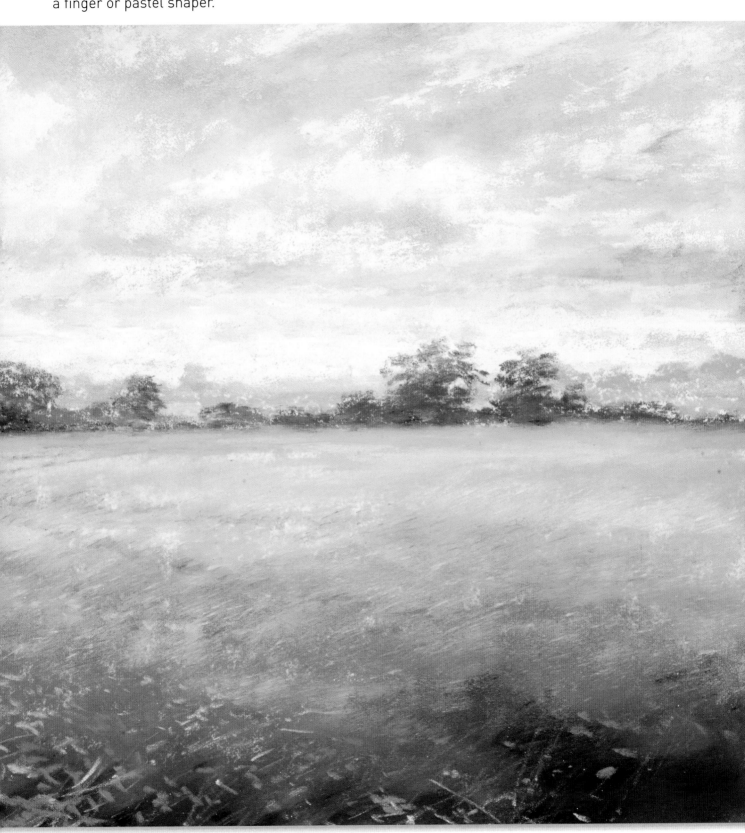

PERSPECTIVE

While aerial perspective concerns spatial light, tone and colour, as we saw on the previous two pages, linear perspective deals with where objects are in relation to each other. We have seen how the use of aerial perspective can create a sense of distance, but the placing of things in a landscape also needs to be carefully considered to make a painting look believable.

When we are drawing shapes with parallel lines, such as buildings, for example, great care needs to be taken to make them look proportional – to ensure that they are correctly foreshortened, and that they recede towards a vanishing point correctly; sometimes complicated angles can leave us baffled as to how to draw them. Eye-level is especially important in this respect because that will affect how the objects look. As your eye-level changes, so do the angles on objects and the vanishing point, and you need to pay particular care to the direction of these angles. In many landscape scenes however, you won't have to worry about a vanishing point, as they won't contain any parallel lines. It's worth paying attention to eye-level though:

High horizon

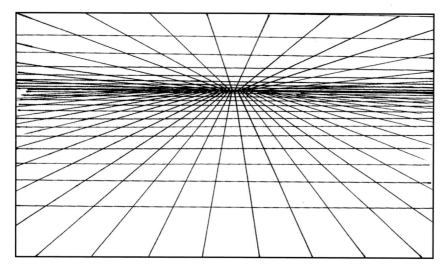

Where there is a high eye-level, less sky is apparent and more land is visible. This might be used where you want a lot of attention to be drawn to the middle distance and foreground.

Low horizon

Where there is a low eye-level we see much more above the horizon. This kind of composition is ideal for a dramatic sky to create a feeling of vast space. I would generally avoid a 50:50 split of land and sky – to be visually pleasing, one ought to be bigger than the other for a harmonious composition.

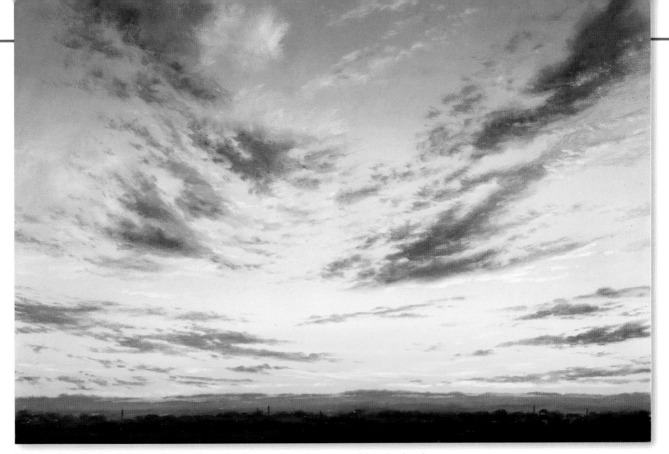

The evening sky in all its glorious colour dominates this picture, making the land much less important; this area is simplified into dark streaks of colour, providing a great contrast with the yellow tones of the lower portion of the sky.

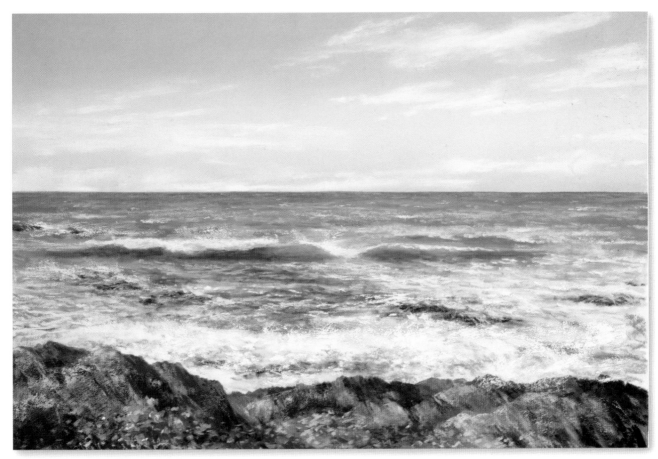

Placing the horizon over halfway up the picture allows the turbulent, dynamic sea to become the focus, sandwiched as it is between the smooth, clear sky and the delicate, colourful foreground.

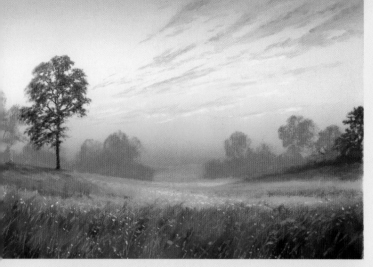

Summer Meadow

Many of the techniques we have learned in this book can be combined to create this lovely final piece. If you don't have all these colours you can easily adapt to suit your own.

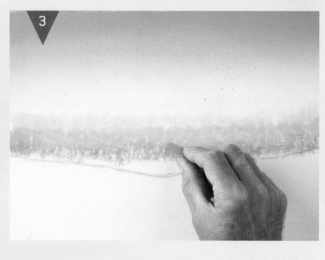

Colours needed

Pale grey, mid-blue, pale blue, white, cream, pale yellow, yellow, orange, red-orange, pale pink, yellow ochre or raw sienna, deep pink, blue-grey or violet-grey, mid-green, light brown, dark green, dark brown and black pastels plus a black pastel pencil.

1. Using the tip of a pale grey pastel, draw a faint line that dips in the middle, dividing the page into two-thirds sky, one-third land. Use the body of the mid-blue over the top part of the sky, then rub in with your fingers.

2. Using the sides of the pastels and gentle pressure, overlay pale blue, white and then cream on the bottom of the mid-blue and a little lower. Blend with your fingers.

3. Under this overlay gentle strokes of pale yellow, beneath this add a brighter yellow, and under the yellow put orange, again using the sides of the pastels.

4. Blend these with your fingers, softening as much as possible, as shown.

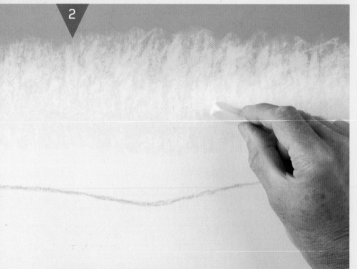

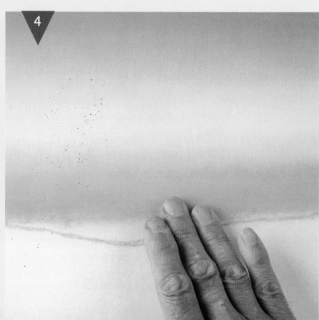

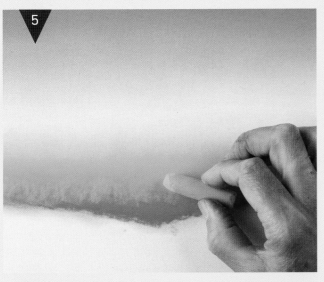

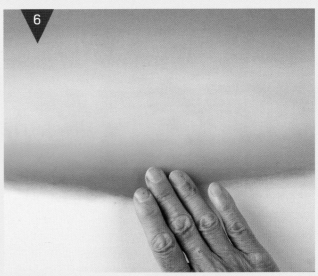

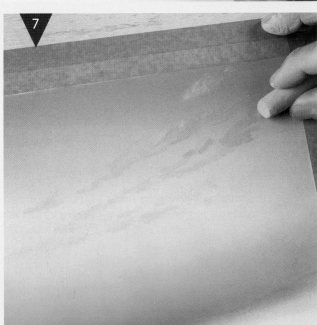

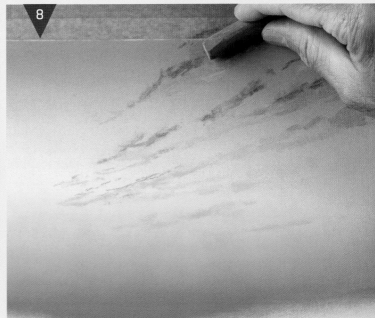

5. Add a bright red-orange at the bottom of the sky and blend it in. If it looks too powerful, add a little yellow to the top of the red to ease it in, using the side of the pastel.

7. Use the side of a pale pink, yellow ochre or raw sienna pastel to create irregular cloud shapes. They should be largest in the top right-hand corner, getting thinner and less clear lower down and into the distance. Add deep pink clouds higher up and to the right.

6. Soften these colours with your fingers, making each colour melt into the next.

8. Use a blue-grey or violet-grey in the same way to create shadows on the upper parts of the higher clouds.

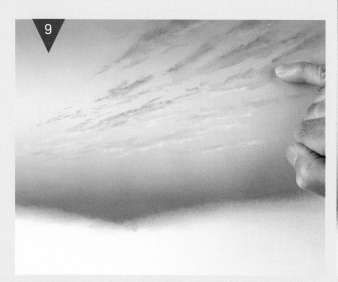

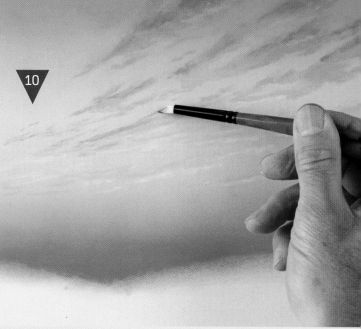

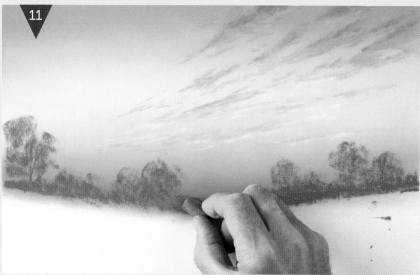

9. Add in highlights on the underneath of some of the lower clouds using a pale yellow or cream. Soften the clouds with a finger or pastel shaper.

10. To create very fine, subtle clouds, transfer a little colour from a cloud using the shaper – touch that colour on to the sky elsewhere. You may need to keep transferring colour to do this or, alternatively, transfer colour from the pastel stick.

11. Using a mid-green, put in the background trees over the orange, either using the body or the tip in an irregular way, so the trees aren't too solid. Use the tip to create tree trunks and any visible branches.

12. Use the tip of a pale blue to create a misty distance between the trees in the middle, then soften with a finger.

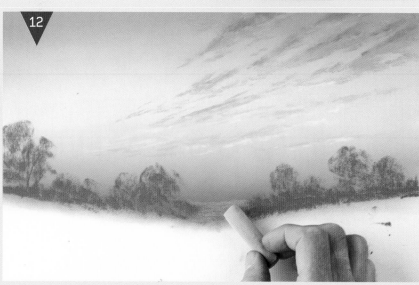

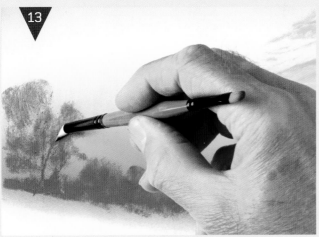

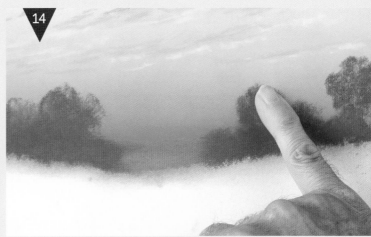

13. Use the tip of the pastel shaper to push the tree trunks or any branches into the paper, to add some definition; a finger might smudge too much in this instance.

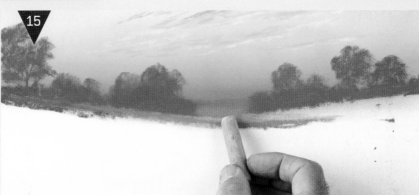

14. Use a finger to soften the edge of the foliage on the trees. Be careful not to smudge too much.

15. Begin to build up swathes of colour in the meadow. Apply lines of yellow ochre or raw sienna underneath the trees using the tip of the pastel. Add in streaks of light brown as well.

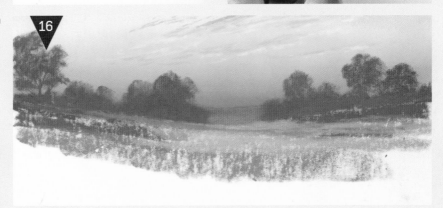

16. Use the pastel body of browns, ochres, oranges or siennas for the middle distance, varying them in strips or partial strips of colour.

17. Apply soft strokes of dark green, dark brown and black along the bottom of the picture using the body of the pastel, and varying the colours.

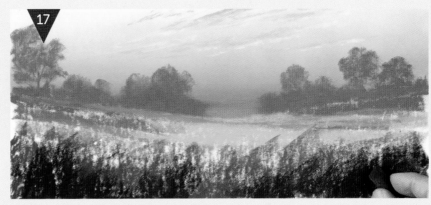

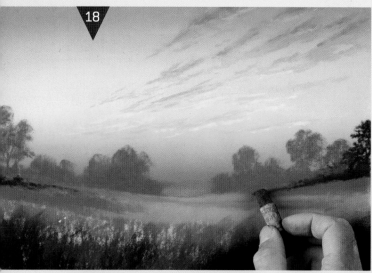

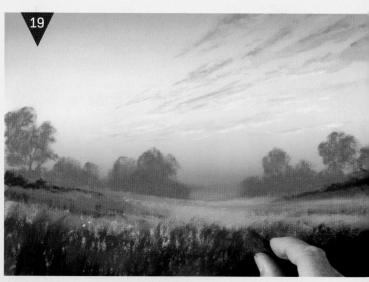

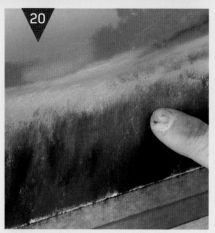

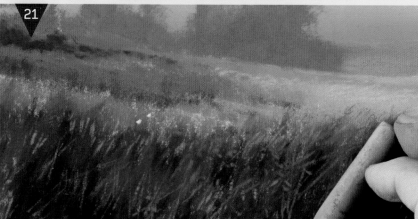

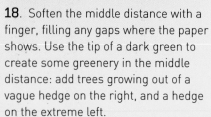

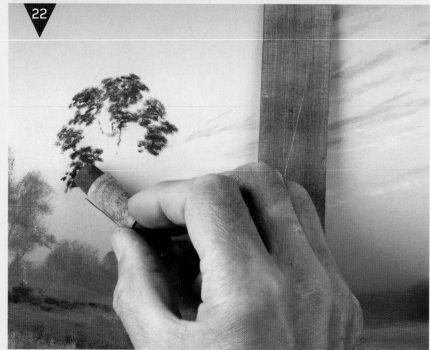

18. Soften the middle distance with a finger, filling any gaps where the paper shows. Use the tip of a dark green to create some greenery in the middle distance: add trees growing out of a vague hedge on the right, and a hedge on the extreme left.

19. Add brown to fill any gaps in the foreground area, and add some soft sweeps of it over the middle distance too, as shown.

20. Smudge the grass area in the foreground upwards and downwards, softening it a little.

21. Use any pale brown, ochre, raw sienna, yellow or orange pastels to create waving foreground grasses. To create very fine lines, hold the pastel at the top and bottom and tap the side onto the dark foreground. Vary the angles slightly.

22. Without too much pressure, use the tip of a dark green to create the foliage on the main tree. Use a ruler to support your hand and prevent it smudging the background.

23. Use the pastel shaper to soften the edges of the tree's foliage a little, pushing the pastel into the paper. Use a very dark brown or black to create the tree trunk and to add in some shadows amongst the foliage.

24. Use a black pastel pencil to create fine branches and to neaten up the tree's trunk a little.

25. Using the tip of a bright red-orange pastel, dab on some colourful poppy shapes. Create larger flowers in the immediate foreground and smaller flowers further away.

26. Add in tiny specks of yellow, white or cream to create other meadow flowers. Be selective about where you put these: add in a few at a time then stand back and assess your piece – you don't want to overdo it.

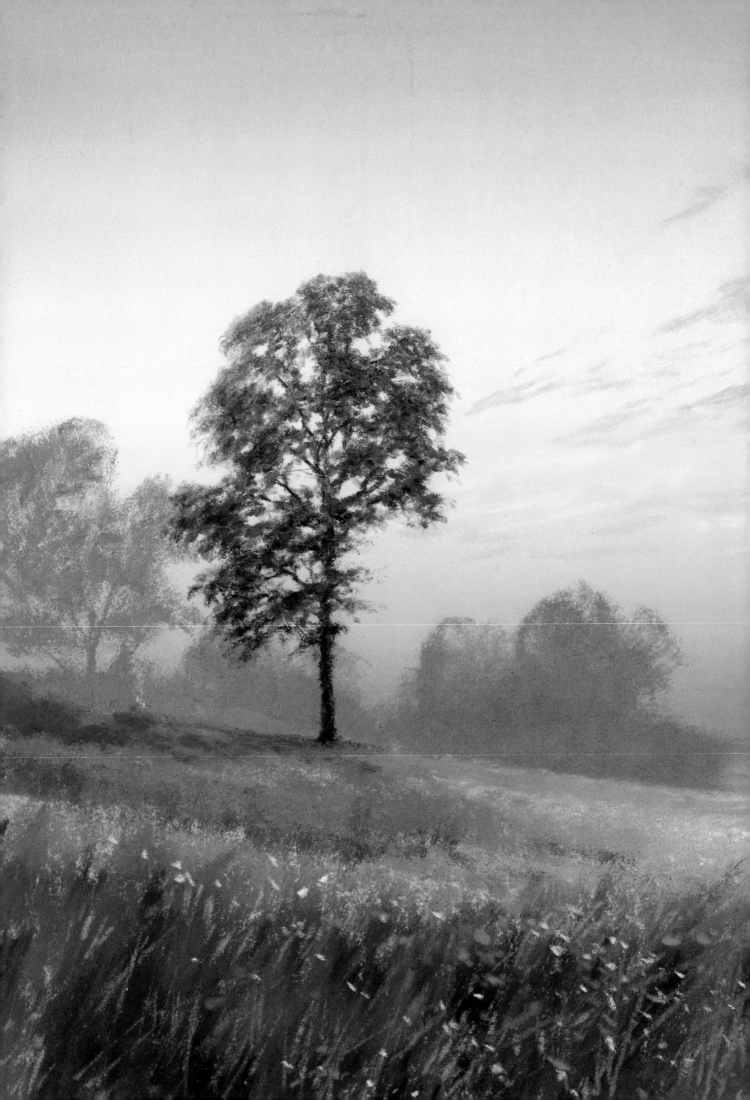

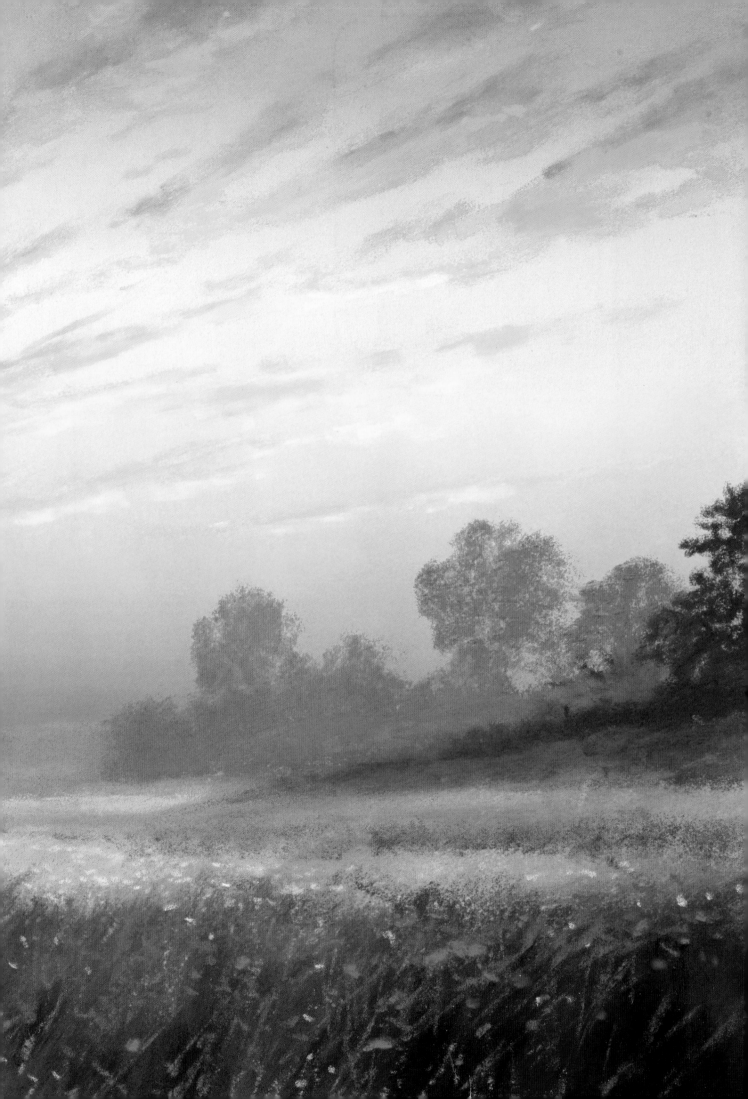

Index

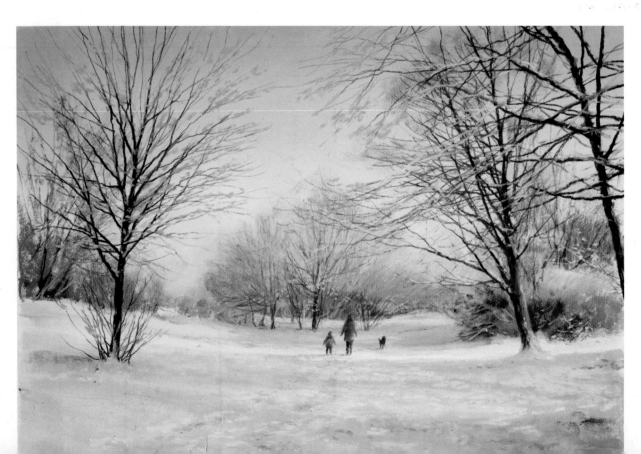